101 MISTAKES
PHOTOGRAPHERS
Should *Never* Make

Lessons from Professionals Who Know

Karen Dórame

AMHERST MEDIA, INC. ■ BUFFALO, NY

Published by:
Amherst Media, Inc., PO Box 538, Buffalo, NY 14213
www.AmherstMedia.com

Publisher: Craig Alesse
Senior Editor/Production Manager: Michelle Perkins
Editors: Barbara A. Lynch-Johnt, Beth Alesse
Acquisitions Editor: Harvey Goldstein
Associate Publisher: Kate Neaverth
Editorial Assistance from: Carey A. Miller, Sally Jarzab, John S. Loder
Business Manager: Adam Richards
Warehouse and Fulfillment Manager: Roger Singo

ISBN-13: 978-1-68203-024-0
Library of Congress Control Number: 2015954504
Printed in The United States of America.
10 9 8 7 6 5 4 3 2 1

www.facebook.com/AmherstMediaInc
www.youtube.com/c/AmherstMedia
www.twitter.com/AmherstMedia

Contents

KEY: ⊘ = DON'T DO IT ⊘ = SOMETIMES OKAY

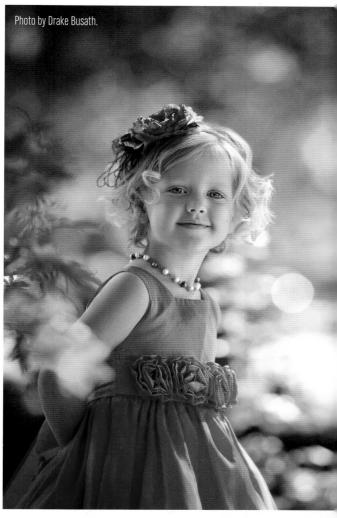

Photo by Drake Busath.

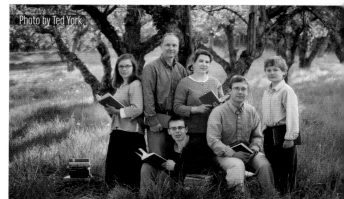

Photo by Ted York.

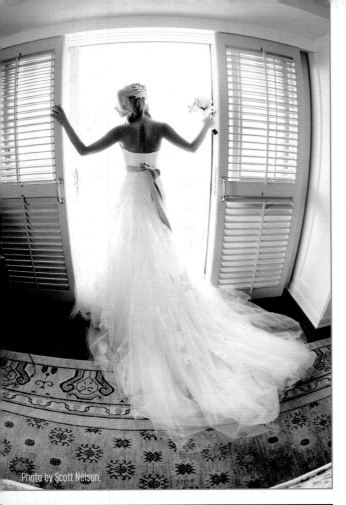

Photo by Scott Nelson.

Photo by Karen Dórame.

Photo by Joel Grimes.

oto by Karen Dórame.

Photo by Karen Dórame.

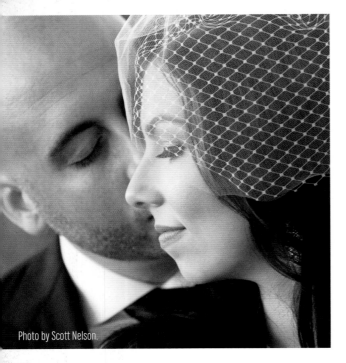

Photo by Scott Nelson.

Photo by Karen Dórame.

Photo by Karen Dórame.

POSTPROCESSING

BUSINESS AND ETHICS

Photo by Jim Garner.

Photo by Karen Dórame.

About the Author

The author grew up in the shadow of her mother's tripod legs and excitedly shot with her first camera while still in grade school. Although she graduated in the field of communications from Brigham Young University, she was able to continue practicing her photographic skills while working in public relations for the Orange County, CA, health department. She retired from public service and co-founded Special Kids Photography of America (www.specialkidsphotography.com) to focus on training photographers to better serve families of children with special needs. She has provided webinars for Marathon Press and presented programs at Imaging USA and regional conventions hosted by Professional Photographers of America. She is the author of *Photographing Children with Special Need*s, *The Photographer's Guide to Making Money,* and *Mastering Infrared Photography* (all from Amherst Media).

Acknowledgments

Mega thanks to all the photographic artists who have made valuable contributions to this publication—as well as for editorial reviews from Ted York, Pam Merrill, Steve Wright, and Alison Miniter.

Contributors

Jennifer Bacher—jenniferbacher.com
Clay Blackmore—clayblackmore.com
Drake Busath—busath.com
Carl Caylor—photoimagesbycarl.net
Jamie Coonts—blujphotograpy.com
Jim Garner—flashfolios.com
Joel Grimes—joelgrimes.com
William Hodge—gradportraits.com
JuliAnne Jonker—jonkerportraitgallery.com
Taylor Lewis
Trish Logan—trishlogan.com
Scott Nelson—sanphotographers.com
Cynthia Pace—cynthiapacephotography.com
Jared Platt—jaredplattphotography.com
Betsy Tomasello—betsyblue.com
Ted York—tedyorkphotography.com
Shannon Sewell—shannonsewell.com
Storey Wilkins—storeywilkins.com

Introduction

Making, Not Taking

While visiting Germany, I entered an art muse-um and asked, "Darf ich hier drin' Bilder neh-men?" roughly meaning, "Can I take pictures inside here?" Although this may be a polite request in English, in German, this entreaty is quite absurd. The security guard gave me an astonished look as he grasped at words to inform me I was certainly not allowed to take any artwork out of the museum. The correct terminology in German is to ask, "May I 'make or create' pictures?" (not "take" them).

This book is all about "creating" photogra-phy, not just "taking" pictures.

What Makes a Photographer Professional?

The art of digital photography has blossomed into a vast world of creative expression enjoyed by myriads more enthusiasts and profession-als than in the not-so-long-ago "olden" days of film. With that, technology has allowed shoddy photography to become rampant. Many would-be pho-tographers are only "technically pass-able" without being "skillfully compe-tent." Cameras have become hand-held robots that bypass

many factors that must work in harmony to create true photographic art.

Not all the points made in this book are actual "mistakes." Some are just options. Most points are basic photographic guidelines—rules that can sometimes be bent or broken to achieve the photographer's artistic vision. However, there is a difference between *break-ing the rules* and *not knowing them*. First, learn and practice the rules; they provide power, confidence, and excellence in the craft.

101 Mistakes is a book about making better choices—about controlling the variables that go into the process of creating professional images, not just pictures. Suppose a photogra-pher comes to a hypothetical fork in the road while creating an image. One path may be a shorter route to the destination; the other may take longer but reveal a more breathtaking vista. The higher, more difficult road is the one that gets top professional photographers the fees they deserve.

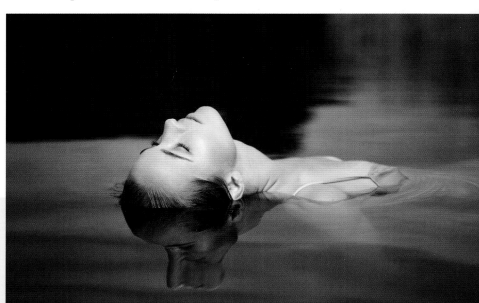

▶ Photo by Joel Grimes.

CATEGORY: PHOTOGRAPHIC GEAR

When it comes to cameras, accessories, and lighting equipment, there are almost endless options. Making smart choices will help put you on the path to success.

MISTAKE 1

Bargain Shopping for Expensive Gear

⊘ **DON'T DO IT!**

Not so fast. When starting out, get face-to-face and hands-on advice from a professional retail camera store. Write down your questions in advance and find a knowledgeable person who can provide competent answers. Quality equipment usually comes with a hefty price tag and is rarely discounted.

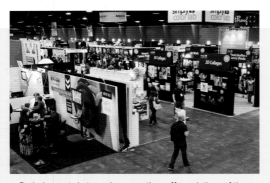

▲ Tradeshows at photography conventions offer a plethora of the latest goods and services.

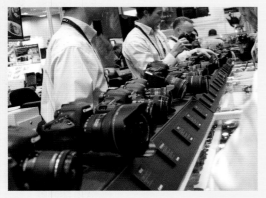

▲ Knowledgeable representatives are available to answer questions about their products.

On-Line Resources

Experienced photographers usually have their eyes on specific products and order from a reputable on-line resource. The key word here is *reputable*. Stay clear of sites that offer products at hugely discounted prices; they are usually bait-and-switch items or scams. Don't hesitate to call an Internet dealer for information prior to making a major purchase. Reliable Internet resources (with a retail store opportunity) for photo equipment include:

- Ace Photo (acephoto.net)–VA
- Adorama (adorama.com)–NY
- B&H Photo (bhphotovideo.com)–NY
- Dury's (durys.com)–TN
- Midwest Photo Exchange (mpex.com)–OH
- Samy's Camera (samys.com)–CA

Photo Conventions

Seasoned professionals often "go to the well" by attending national photography conventions that offer an abundance of inspirational classes and a plethora of products. Set aside time to attend at least one national photography convention each year. Instructional programs will inspire and the trade show will offer the best opportunity to check out the latest photo gear. Photography conventions with instructional programs and photographic products include:

- ImagingUSA (ppa.com)—Convention/trade show rotates annually to different locations.
- WPPI Conference & Expo (wppionline.com)— Held yearly in Las Vegas.
- PhotoPlus International Conference & Expo (photoplusexpo.com)—Held annually in New York City.
- Regional PPA conventions and trade shows (ppa.com)—California, Utah, Texas, Oklahoma, Maine, Louisiana, New England, etc.

H old on. Many aspiring photographers who purchase a professional level-camera merely set it on "auto" or "program," hoping to coast along on the technology until they learn how to wrestle the manual settings into submission. Trusting the camera to make all the decisions (especially in low light conditions) is a huge mistake. Cameras sometimes get confused and spit out nasty results—and the opportunity to use creative lighting goes out the window.

Before investing bundles in a pricey camera, get a firm handle on manually balancing the aperture and shutter speed settings in order to have the camera completely under your control. Become so familiar with how to operate your camera on manual that it's like operating a microwave. Why? As Kirsten Lewis (kirstenlewisphoto.com) says, "If you are so stressed about your camera and the settings

Spending a Lot for the Most Automatic Features

🚫 DON'T DO IT!

you are trying to figure out, you have no space in your brain for creativity."

66 Trusting the camera to make all the decisions is a huge mistake. 99

▲ Just because a camera has a lot of whiz-bang settings, don't assume it will get everything "right" under any shooting conditions. Learn how to configure the manual settings. Different cameras will offer different options for manual settings.

▲ Most professional cameras have a small info panel for making a quick check of settings that regulate exposure.

▲ Set camera dial on M for Manual and learn how to quickly dial in correct exposure settings .

MISTAKE 3

Expecting an Expensive Camera to Last for Life

🚫 DON'T DO IT!

Who are you kidding? Technological advancements accelerate at an astonishing rate every year. Cameras are no exception. Buy and keep quality *lenses*, but retire the *camera* when periodic updates in new models are worth the replacement. A professional photographer benefits from improved camera features that are updated with even better capabilities in the next model. Increased pixel capability is not always the supreme aim; pixel power needs to be valued along with all the other new features and increased capacities that come along.

Keep in mind that a digital camera may wear out after a certain number of "clicks" (actuations). Although some mechanisms on the camera can be replaced, would you buy a computer and expect to simply replace parts for years? Carefully review the equipment or lease it on trial prior to purchase. A ten-year-old camera might as well be as old as this 1915 Seneca Folding Scout camera.

► It is fun to read the details about this 100-year-old Seneca camera that could be purchased for a whopping cost of $8 in 1915.

▼ Old cameras get older at a faster speed in the digital world. They should be replaced with new technology.

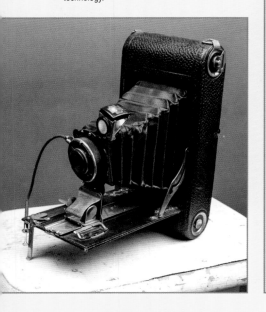

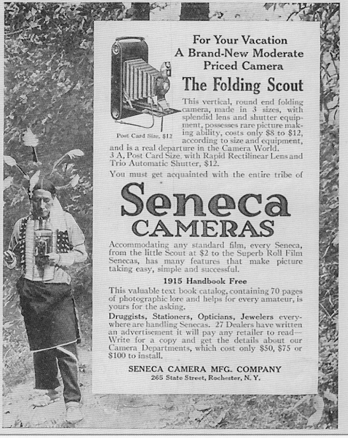

D on't go on a crazy buying frenzy when starting out in photography. Set a reasonable figure and stay within your budget. Most likely, your client will not know whether your tripod cost $300 or $3000. They only want to have confidence in your ability to get the job done in an impressive way.

Of course, quality equipment can be a rock-solid investment that is not just for show. Thoroughly research photographic equipment before investing in it by consulting a mentor in the business, reading reviews on the Internet and in professional photo magazines, and testing gear at trade shows. All the while, keep in mind that "more expensive" is not necessarily better. Build a business with the basics until you can afford better.

Ask yourself—and answer—these important questions:

- Will this item be used to support my current focus in the business?
- Will I use this item enough to make it pay for itself?
- Have I asked the advice of someone who uses and recommends this item?
- Have I budgeted for it?
- Have I read reliable reviews about this product?
- Have I allowed time to cool my eagerness to buy on impulse?

$5,000 Start-up Gear for a Photo Business
Cameras (Figure $2,000–$2,500)

Camera models change every year or two. You don't have to purchase the most recent Nikon or Canon, but you can often still buy the previous model new-in-box. If you started with one brand, it is advisable to stick with it and start assembling good lenses for that brand.

At the very least, learn about cameras and the different sizes of sensors. A sensor affects the quality of a photograph. Although there

MISTAKE 4

Mortgaging Your Home to Outfit Your Photo Studio

⊘ **DON'T DO IT!**

▲ APS-C crop sensors (compact) provide fewer pixels.

▲ Full frame sensors (35mm) offer more pixels.

are several sizes of sensors available, two outsell most of the others: the APS-C crop sensor and the full frame (35mm) sensor.

If going professional, consider acquiring a camera with a full frame sensor (instead of the smaller crop sensor) in order to get higher ISO performance and more pixel power. An

even higher level (and price tag) of profession-
al camera can be reached with medium format.
But know this: once you have moved on to
a larger sensor, it's difficult to go back to the
smaller one. Also, remember that the person
behind the camera is the most important fac-
tor in creating quality images. That said, many
photographers are discovering the pleasure of
packing along a micro 4/3 mirrorless camera.
These cameras have a lot of enticing features
besides being great performers.

Lenses (Figure $1,000–$2,000)

Although lenses suggested here are popular
with professionals, it doesn't mean they are the
very best for your personal style or genre. The
best lens choice will also depend on the brand
of camera and the size of the sensor (discussed
above). Although purchasing used cameras is
not recommended, pre-owned lenses may be
a viable option to consider—as long as they
come with a money-back guarantee.

Prices tend to vary only slightly between
relatively equivalent Canon and Nikon lenses.
However, the same focal-length lens from a
non-OEM (original equipment manufacturer)
company like Sigma or Tamron may save you
a few hundred dollars. The lenses from these
providers are constantly improving, but do
your research carefully. Even within the same
line, aftermarket lenses can vary substantially
in quality when compared one-on-one to the
equivalent lens offered by a major camera
manufacturer.

If purchasing a lens for a crop-sensor
camera, something to think about is whether
it will also function correctly with a full-frame
camera when you eventually upgrade. Some
(but not all) lenses used on crop cameras
will produce vignetting around the edges of
a full-frame image. This can be problematic

▲ This was shot with a 18-70mm DX kit lens, which I usually use only for
infrared shots on an IR-converted crop sensor camera (because cheaper
lenses don't create hot spots). Here, I accidentally attached it to a full
frame camera—and you can see the vignetting it produced.

Starter Lens Suggestions

- 35mm f/1.4 prime ($899 for Sigma)—This
 lens is a little-known gem. Great for
 all-around use
- 24–70mm f/2.8 ($1,500–$2,000 for
 Nikon or Canon)
- 50mm f/1.4 or f/1.8 prime ($100–$350
 for Nikon or Canon)—A 50mm lens is also
 good to use for video
- 70–200mm f/2.8 ($2,400 for Nikon or
 Canon)—requires a bit of space between
 you and the subject

Suggestions for Different Genres

- Family and Child Portraits: 24–70mm,
 50mm prime, 35mm prime
- Groups: 24–70mm or 24–105mm
- Newborns: 50mm prime
- Landscapes: 16–35mm, 24mm,
 70–200mm
- Sports: 70–200mm f/2.8 is the most
 widely used for sports. Also check out the
 100–400mm f/4.5 and 400mm
- Real Estate: 10–24mm, 17–55mm (crop),
 14–24mm, 16–35mm, 17–40mm
- Weddings: 50mm, 70–200mm (for a
 short distance), 24–105mm or 24–70mm
 (walk-around lens), 85mm
- Wildlife: A much bigger investment is
 needed for photographing critters out in
 the wild
- Video (light use, non-professional): 50mm

to remove in postproduction. Therefore, if you have a crop camera, it is a good idea to purchase a lens that will also be appropriate for a full-frame camera.

Initial Lens Purchase. Start out by selecting a good all-around lens that will be useful in a variety of situations. For instance, a 35mm prime may be used in weddings, for family shots, as well as for photographing newborns—but it may not be versatile enough for sports. Make a mental note that cameras have become the accessories; quality lenses should be thought of as "keepers" after a camera is retired.

Zoom vs. Prime Lenses. Simply explained, there are two main types of lenses: zooms and primes. A zoom is capable of moving in and out, while prime lenses have only one focal length, requiring photographers to "zoom" with their feet.

Lenses that are capable of an ultra-wide aperture will generally have a higher price tag. For instance, a 70–200mm zoom with f/2.8 aperture will cost almost twice as much as the 70–200mm f/4 version.

Lighting Equipment

Hot lights (incandescent bulbs) were used in the beginning days of studio photography and continued to be a standard for many years. However, they often caused subjects to perspire, so makeup would melt and children would run away squealing. Hot lights also had a short lifespan. Eventually, newly invented strobes gained in popularity, overtaking hot lights as the standard for studio lighting.

Strobes and their triggers have a learning curve and require experimentation to achieve the best results. Some photographers tend to repeat the same static lighting setup with clients because switching it around requires re-metering, re-setting, re-placement, re-trying, etc. If the "formula" changes in any way, the dance of the lights begins again.

Strobe lighting is a big investment, and it will take some grit to sort it all out. Also, all the electrical components may present snafus—with the potential to ruin a shoot. Therefore, I suggest starting with the easier route by equipping your studio with daylight-balanced fluorescent lights (a cool, continuous light source), which are dependable and a simple pleasure to set up and use.

Learning how to use photographic lighting equipment can be intimidating at first. Instead of setting it in the corner to gather dust until you get up enough courage to try it, just jump in and keep practicing until you catch on. One of the best ways to learn how to use new equipment is to soak in the valuable person-to-person instruction offered at national and local conventions, as noted in section 1.

There are all kinds of lighting options to explore that can cost from $10 to $10,000. Let's look at a few of them.

Natural Light and Available Light (Free—Almost)

Shooting on location with natural light is a great first choice for beginning a business. Outdoors, lighting is free—but, for the most part, tools are definitely needed to control it. For working outdoors, learn how to use bright light and shaded light correctly. For instance, it helps to be prepared to bounce light back into the face of a subject by using a reflector when a boost of light is needed.

On a sunny day, a scrim (a light-diffusing panel held over subjects' heads) is useful for softening deep shadows under eyes and noses. To spare sizable expense, you can construct a large scrim by attaching parachute rip-stop fabric to a frame made out of PVC piping.

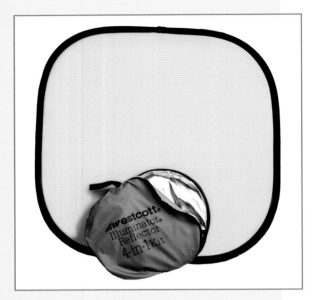

▲ Reflectors, such as these from F.J. Westcott, are fairly inexpensive. An even more affordable choice is a sheet of foam board or heavy white poster board.

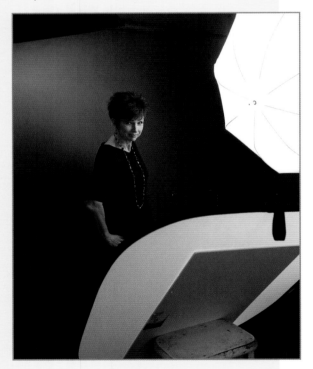

▲ Reflectors are easy to place, adding a boost of "bounced" light where needed. Barely shown here (upper left corner) is a hair light. Also shown is a softbox with a bank of daylight-balanced lights inside, and a propped-up translucent reflector that can also be used as a scrim to filter light and eliminate harsh shadows. These lighting tools are from F.J. Westcott.

However, if wind is present, a larger reflector may sail you across the landscape!

For an indoor or studio-type setting, a large north-facing window is ideal for lighting a subject.

Reflectors and Scrims (Figure $40)

Reflectors are a must for both natural and artificial lighting scenarios. Their price has come down significantly in recent years. Presently, a set of these modifiers of light can be found for under $10 on amazon.com. For a few dollars more, invest in a trustworthy five-in-one set by F.J. Westcott, a dependable supplier of professional lighting equipment to photographers.

A reflector kit usually includes a scrim of white translucent fabric that can be used not only as a reflector but also as a sun filter on a bright day. For transporting, you can fold the reflectors into their nifty carrying case. To eliminate the need to hold a reflector, try using a stand with a boom arm. Get one for under $25 from Limostudio. Don't have a reflector kit? Plain white or black foam board also works to add (or subtract) light.

Speedlights (Figure $500)

Reasonably priced aftermarket off-camera flash units (speedlights) are flexible, lightweight lighting options. Phottix comes highly recommended. Scott Kelby offers a Phottix set for $499.99 (shown at the top of the facing page) that comes with a light stand, two modifiers to soften the light, Odin wireless trigger, and more (bhphotovideo.com). Speedlights have become very popular in recent years. They don't crank out as much light as strobes, but brackets are available that let you group several units together for greater light output. Fairly recently, small, collapsible, umbrella-like light modifiers have become available to regulate

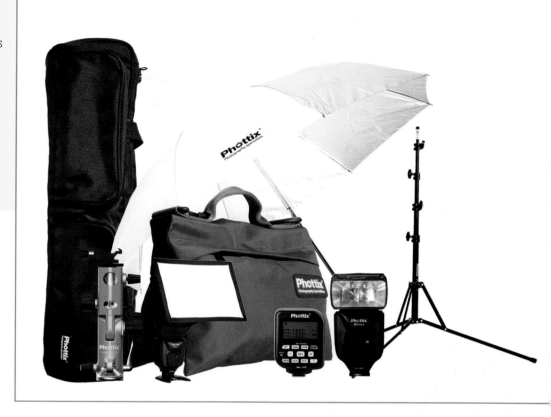

► When starting out, investigate cost-effective lighting kits. This is the Scott Kelby collection by Phottix.

the light from speedlights. Professionals who use artificial lighting on location use various types of lighting units that are easy to set up and take down.

Daylight-Balanced Cold Continuous Studio Lighting (Figure $500–$2,000)

Many photographers are now converting to a cold continuous lighting system because it is more flexible, has fewer mishaps and outages, does not require recycle time, and allows freedom to adjust lighting in a "what you see is what you get" manner while you are posing the subject.

F. J. Westcott has a continuous lighting system called Spiderlites, available through the distributors listed on page 20. These lights are very efficient for a studio. The six bulbs inside the unit can be adjusted on and off with three

▼ More and more professional photographers are discovering the comfort of using daylight-balanced studio lights that take very little "math," have fewer glitches, and less downtime. F.J. Westcott is a reliable "go to" source for affordable continuous lighting options.

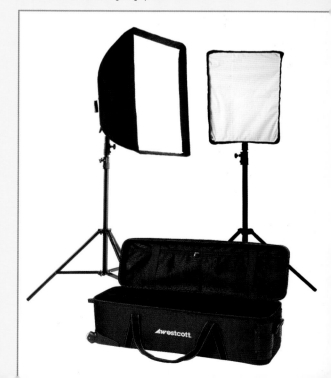

switches that provide different levels (stops) of light output. The softboxes come in different sizes, with a carrying case included. Setup is easy and the bulbs are easily changed when they burn out—but they last a long time.

Strobe Lights (Kits begin at $400)

Many successful high-end professionals started out with AlienBees strobe lights, then moved up when the budget allowed. Paul C. Buff (paulcbuff.com/plm.php) is a reli-able Internet distributor of all types of photographic lighting, including their "Beginner Bee" kit for under $400. The kit includes a parabolic umbrella that is extremely efficient in providing even coverage with little light falloff at the edges. This is ideal for portraits, group photos, weddings, etc.

- One AlienBees TM B800 flash unit
- One general-purpose light stand
- One 51-inch white umbrella-type diffuser
- One 51-inch black umbrella cover
- One carrying bag

If this starter kit does not exactly fit your needs, it is possible to consult with Paul C. Buff for equipment that will work well for your specific needs.

Other Lighting Options (Figure $20–$200)

For on-the-fly lighting of very still objects (like a wedding cake), try a trigger-activated industrial-type flashlight (used with West-cott's Micro Apollo modifier) to "wash over" or "paint" a non-moving subject with light. Even more popular, practical, and affordable LED lights are available in all shapes and sizes.

POWER CORD
to AC outlet

SYNC CORD
from flash (1/8-inch)
to camera (PC connection)

▲ All types of lighting kits are available. Find one with the components that best suit your needs.

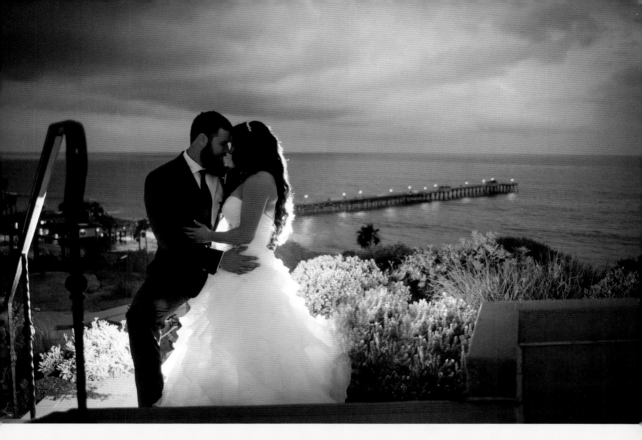

▲ Have small LED lights at the ready in your gear bag. Use your imagination to place them where they will provide an extra bit of punch to an image (and where light spill will be minimized). Photo by Scott Nelson.

▶ **TOP RIGHT** – LED lighting comes in all shapes, sizes, and prices. Here is where "cheap" might compare favorably to "expensive."

▶ **BOTTOM LEFT AND RIGHT** – An older method of "on the go" lighting is with a trigger-actuated industrial flashlight. Press the trigger and "paint" your desired subject with light.

Some photo-specific LED units can be pricey, but substitutions can be made for more reasonable investments. What's more, most LED lights are battery-operated, making them extremely portable and adaptable for illuminating cakes, adding light behind a veil, rim lighting, etc.

In the image above, Scott Nelson used portable lighting to highlight the bride's dress as the sun descended.

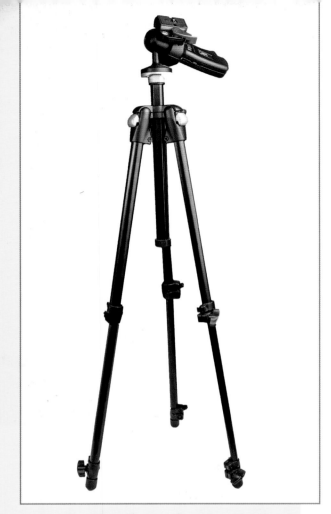

▲ This model 3001 Manfrotto (Italian made) is a sturdy studio tripod. Although discontinued, a similar model is available for about $200.

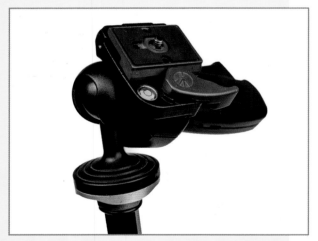

▲ The head of a pro tripod is usually sold separately to fit the need and preference of the photographer. This is a grip action ball head 322RC2 Manfrotto (under $200).

Background Supports (Figure $50–$100)

Background support stands are available from F.J. Westcott, Square Perfect, Savage and many more. Background stands will support fabric as well as rolls of background paper, which come in a variety of colors and sizes (as pictured in section 29).

Tripod (Figure $250–$350 Minimum)

Until your budget allows, don't go wild with your first tripod. That said, get a sturdy one that is flexible for a variety of situations—unless you know the *exact* photographic path you will be following. Don't settle for a flimsy tripod either. Manfrotto offers a reasonably priced tripod with a grip action ball head.

> 66 Until your budget allows, don't go wild with your first tripod. 99

Resources for Gear

There are several reliable Internet sites that offer both new and used equipment as well as professional advice. These are presented below in alphabetical order. Amazon is a good resource if you are not exactly sure of what you want.

- adorama.com
- amazon.com
- bhphotovideo.com
- borrowlenses.com
- cameta.com
- drurys.com
- mpex.com
- samys.com

Skipping the Tripod with an Image Stabilization Lens

🚫 DON'T DO IT!

This warning is only partly true. Tripods can be a matter of preference—or what a certain type of photography dictates. While a tripod may be cumbersome to drag along outdoors, professional landscape photographers are rarely seen without one. Conversely, in other genres of photography, it's preferable to move around the subject with flexibility. The ability to capture different angles by hand-holding the camera is especially useful for hovering over a newborn or creatively capturing the blithe spirit of a teenager flitting around in her hot new outfit.

Quality lightweight tripods are available, but they come with a big price tag. A carbon-fiber tripod can run over $3,000—and don't forget the head! Cutting corners by buying a flimsy tripod for outdoor photography is unwise because a strong gust of wind can topple the tripod along with your camera.

MeFoto makes the "Globe Trotter," a sturdy travel tripod that has a loop under the head to hang a weight for added stability. The legs fold up on themselves to fit snugly in a small case. Some models can be disassembled to become a monopod.

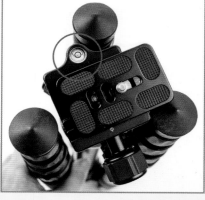

◄ MeFoto tripod folds up on itself and fits into a smaller than normal case.

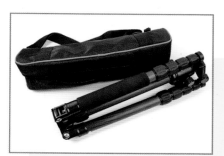

◄ Looking down to the top of the tripod, check out the level and quick-release plate.

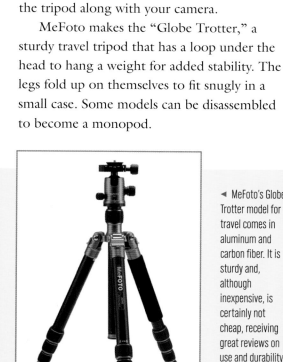

◄ MeFoto's Globe Trotter model for travel comes in aluminum and carbon fiber. It is sturdy and, although inexpensive, is certainly not cheap, receiving great reviews on use and durability. The head even has a tiny built-in level for getting the horizon straight.

◄ Adjustment knobs on the ballhead are compact for lessening weight and bulk.

MISTAKE 6

Choosing Megapixels Over Sensor Size

🚫 SOMETIMES OKAY

D o today's high-megapixel capabilities eliminate the need to buy a camera with a full frame sensor? Let's not rationalize here. Simply said, most mid-range professionals buy cameras with a full frame sensor (vs. a crop sensor) to get better results.

I once heard someone say that using a crop sensor (APS-C) camera is like saving the middle of an image and throwing away the outside edges. If a sensor is 24x36mm (the full size of a 35mm film frame), there is no "crop factor." In general, full frame sensors have better image quality across the board, and they excel when it comes to high ISO performance.

Nevertheless, if you already own a crop sensor camera and are getting good results, don't rush out and purchase a full frame model until you are ready.

> 66 Full frame sensors excel when it comes to high ISO performance. 99

▼ Image size comparison between a crop sensor and a full-frame sensor.

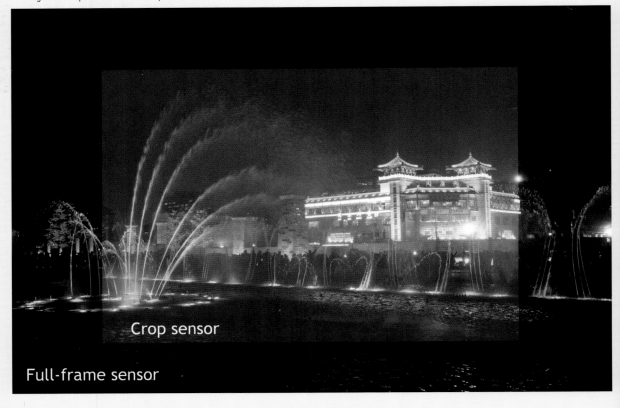

Crop sensor

Full-frame sensor

Don't sell them short. Mirrorless cameras may be the way camera engineering is headed—then again, maybe not. Although revolutionary features are currently in place with mirrorless technology, professionals aren't generally seen using these pint-sized gems in public with clients. Let's face it, appearance (and size) is important. Small mirrorless cameras don't give the same impression as meaty, bad-boy, professional gear.

That said, several features available on quality mirrorless cameras are impressive. Most models of mirrorless cameras have live view technology for evaluating the shot through the LCD panel as well as through a viewfinder. Some LCD panels lift up or down, helping you shoot from overhead or low angles without having to sprawl out on the floor (or, worse, the muddy ground). Touch-screen LCD panels also allow the user to finger-skim through photos as on a cell phone or iPad. I like the "what you see is what you get" feature that shows the exposure through the viewfinder (not just after you click the shutter).

Although the new Olympus OM-D EM1 mirrorless camera is small in size, the image above (created by an earlier model) was of high enough quality to be accepted by a leading stock photo company, where reproduction quality is paramount.

Regarding Mirrorless Cameras as a Passing Fad

⊘ DON'T DO IT!

▲ The image quality of the mirrorless camera is suitable to be accepted as stock photography.

Advantages of Mirrorless Technology

- The image quality is quite good
- A variety of lenses to choose from
- Shooting speed equals or can exceed DSLRs
- Quieter (no reflex mirror as on DLSRs)
- Tilt the back LCD panel up or down
- Live view gives exposure display
- Shoot nice video and continuously autofocus while recording

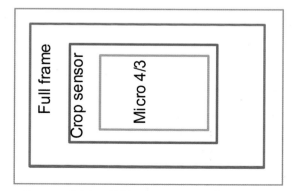

Full frame | Crop sensor | Micro 4/3

▲ The comparative sizes of full frame, crop, and micro 4/3 sensors.

MISTAKE 8

Purchasing a Lens/ Camera "Kit" to Save Money

🚫 DON'T DO IT!

Think about it. With a camera "kit," buyers pay only $100 (approximately) over the base price of the camera in order to get the lens, too. However, a *quality* lens might cost $1,000 or more. What's wrong with this picture?

Excellent advice to an aspiring professional is to invest in lenses with at least f/2.8 or wider aperture capability (*i.e.*, f/1.4, f/1.8). These lenses will allow more light to enter under low-light conditions and also provide creamy, out-of-focus, bokeh effect in the background. A sure mark of a professional image is a lovely bokeh (blurred background) behind the subject. More about bokeh in sections 13, 14, 21, and 50.

Try the Kit Lens for Infrared

My first "big girl" camera was a Nikon D200 (2005) that came in a kit with an 18–70mm f/3.5–4 lens. Because I also bought Nikkor 17–55mm f/2.8 and 70–200mm f/2.8 lenses at the same time, I didn't use 18–70mm kit lens until years later when I took up infrared photography by converting the same D200 for black & white infrared capture. As it turned out, kit lenses can be very effective for use in infrared photography—often preferable to high-end coated lenses!

> 66 A sure mark of a professional image is a lovely bokeh (blurred background) behind the subject. 99

▲ "Kit" lenses are often not the best to use for professional work. However, they can perform better than high-end coated lenses for infrared photography.

▲ Always keep the boxes your equipment comes in. It helps for resale down the road when you replace the item.

As noted in section 4 (page 15), lenses can be divided into two categories: zoom and prime. A zoom lens moves in and out, making the subject appear farther away or closer in the image (without the photographer changing position). With a prime lens, you must walk the camera forward or backward to change the size of the subject in the image.

Both zoom and prime lenses have their advantages. A professional photographer will often favor either zooms or primes, depending on their habits, subject matter, and personal style. The versatility of zoom lenses makes them a reasonable choice—but prime lenses are a joy to use and tend to be sharper (a big advantage!).

> 66 The versatility of zoom lenses makes them a reasonable choice—but prime lenses tend to be sharper. 99

Carefully study gear used by professionals working in a particular genre (wedding, sports, family photography, etc.); this is a good endorsement for the correct lenses to purchase. For example, most professional portrait/wedding photographers rave about their 70–200mm f/2.8 zoom lens. There may be other lenses in their gear bag, but this big daddy telephoto zoom is almost always part

Choosing Zooms Instead of Prime Lenses

⊘ DON'T DO IT!

▶ **TOP** – Zoom lenses have their place, especially the sweet 70-200mm f/2.8 telephoto. Another popular configuration in this category is the 24-70mm f/2.8.

▶ **BOTTOM** – Prime lenses are generally smaller in size and sharper in focus. They are often favored over zooms for professional work.

▲ Focus is incorrectly placed on the girl's button in this shot using an 85mm f/1.4 lens opened wide to f/1.4.

of the collection. The many layers of glass inside make the 70–200mm a hefty one to lug around and hold up to your eye for very long if you are not using a tripod.

The 50mm f/1.4 prime is a standard "go to" lens among portrait, newborn, and wedding photographers. Prime lenses are generally smaller than zooms and—of course—a lot lighter because there is not as much glass inside.

When shooting at the very wide apertures many prime lenses allow, there are some important focus issues to be aware of (be sure to check out the photo examples to the left).

Zoom Lenses vs. Prime Lenses

- Primes are usually sharper than zooms, but not always.
- Prime lenses are usually smaller than zooms and a whole lot lighter.
- More light enters the camera through a lens with a wide aperture.
- Wide apertures also produce dreamy bokeh in the background.
- Is the expensive price tag worth it for your style of photography?
- A variety of prime lenses in different focal lengths are needed to make up for zoom capability.
- There may be a slight learning curve about the nuances of focus with certain primes.

▲ Although not perfect, the focus here on the face is improved, using the same aperture with a "focus and recompose process" – because she was rolling around too fast to move the focus point around the matrix. (More on different focusing methods later in the book).

MISTAKE 10

Buying Only OEM Lenses

⊘ DON'T DO IT!

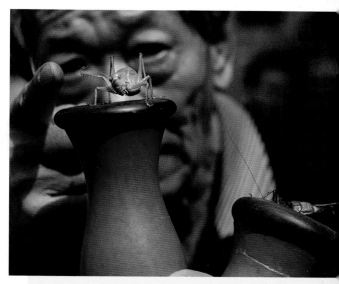

Have you ever been told that you should *always* buy lenses that are the same brand as your camera? Well, here's another bit of advice: Beware of advice that includes the word *always!* In many cases, non-OEM lenses (ones that are not made by your "original equipment manufacturer") could be an excellent choice.

That said, thorough research is advised prior to investing a non-OEM lens. Some aftermarket lenses are fantastic; others are not so great. There is no assurance that they will have the same performance as Nikkor or Canon lenses of the same focal length. Before investing, read lens performance reviews on the Internet and in photo magazines. Also, ask the opinions of people who use the lens that interests you. You can also try renting a lens for a "test drive" before buying.

I made the surprising jump from my collection of Nikkor lenses to a Sigma 35mm f/1.4 when I was looking for a not-so-big, not-so-heavy lens for travel in China. In this case, it wasn't the price that sold me (a savings of about $200)—it was the quality. These examples shot in China with my Sigma 35mm f/1.4 lens show how a very short depth of field clearly isolates the subject, while telling the rest of the story in the background.

▶ **TOP**–A prized fighting cricket poses for his "close-up."

▶ **BOTTOM**–Sharpness brings the subject into clear focus and allows a secondary story to play in the background.

▼ The Sigma 35mm f/1.4 lens.

MISTAKE 11

Using Fisheye Lenses Only for Gimmicky Shots

⊘ DON'T DO IT!

Fisheye lenses are pricey (around $700, give or take) but they have a lot of potential—if you know how to use them correctly. Think of fisheye lenses like costly saffron seasoning; it needs to be used sparingly, but dishes prepared with this delightful flavoring are usually haute cuisine. Throw one or two fisheye shots into your wedding coverage for extra pizzazz.

Using a fisheye correctly requires practice and discretion as to when and where it is appropriate (mainly on non-moving subjects, for starters). Any object that needs to stay straight (with no warp) must be placed in the middle of the frame. For a horizon not to bend, it needs to be aligned smack across the "equator" of the image.

Practical Examples

Scott Nelson's beautiful bridal image (facing page) is a great example of correct placement of subject in a fisheye shot. Coincidently, the divider panels of the middle door slats are positioned in the right place to run straight across the image horizontally with very little warp. Of course, the bride has to be in the middle of the frame to keep her from bending out of shape (that's usually the role of the mother of the bride).

These images from the Netherlands (below) demonstrate how a rather mundane image can be turned into something that invites the viewer to look twice. The "made you look" image on the left was obviously created with a fisheye lens (16mm). The horizon is flat because it is in the middle of the frame, whereas the straight road outside the window is depicted as curved because it is nearer the bottom of the frame.

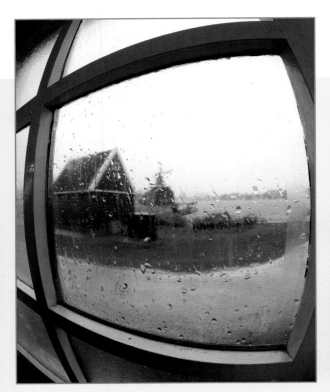

▶ **FACING PAGE**—Scott Nelson positioned the bride perfectly for this fisheye portrait.

◀▼ A normal window (below) and a normal scene outside—sort of blah, right? Shooting it with a fisheye lens (left) transformed it into something much more interesting.

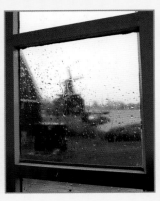

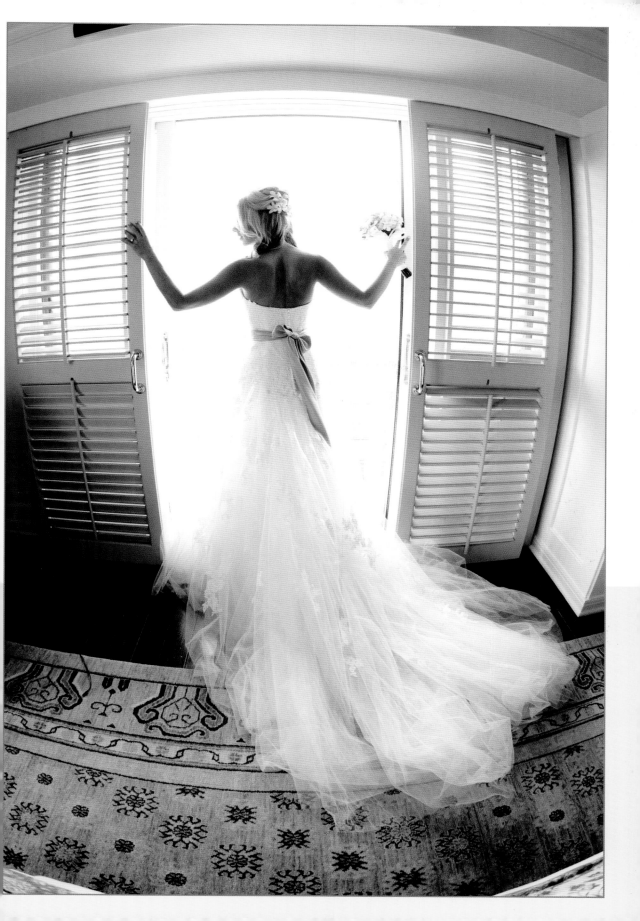

MISTAKE 12

Using Only Pro Gear Bags

⊘ DON'T DO IT!

▲ To make your gear less attractive to thieves, cover any brand names with black tape.

▲ When on the road, get easy access to a camera by swinging the Lowepro Flipside pack off your shoulder and grabbing the equipment from the side.

Which bag you should use depends on who you are trying to impress. If you have a glitzy engagement shoot, go ahead and carry that impressive gear bag to hold your equipment.

Beware of Wedding "Stalkers"

However, think twice about impressing a thief. A wedding photographer may want a larger container on wheels to house a variety of lenses, lights, and gadgets. That means it will need to be on the ground—and probably out of the photographer's sight for some of the event. Uninvited guests have been known to "stalk" weddings just for the purpose of stealing unwatched equipment.

Use Caution When Traveling

When you're on the road, follow the lead of some travel photographers who replace blazing Nikon and Canon straps with a nondescript version. They block out any kind of reference to "camera"—especially brand names—and help avoid calling unwanted attention to your camera equipment.

The very safest transport of sensitive equipment to far-off lands is with a heavy, hard-shell case. But if you can't afford a Sherpa and are able to get your gear into a carry-on backpack, there are many brands that have securely padded cells for camera and lenses.

A popular configuration is one offered by Lowepro that has a side opening for swinging it off the shoulder to get easy access. The hip support not only distributes the weight, it also makes it harder for a passing cyclist to snatch it off your shoulder.

The "100%" part is what's wrong with this advice. Learning to shoot in manual is important (see next page), but sometimes it is more important to use a semi-manual mode. If you might need to switch settings quickly (such as when moving from sun to shadow), manual will not be the best choice. In cases where shooting quickly is important, it often makes sense to lock in the aperture or shutter speed (whichever is more important to the circumstance) and let the camera make the rest of the calculations in order to reach a reasonable exposure. For example, you might want to lock in a shutter speed of $\frac{1}{400}$ or $\frac{1}{600}$ second to freeze action and let the camera automatically pick an aperture setting that provides adequate exposure.

Aperture Priority or Aperture Value (A or Av)

When aperture priority is chosen, you set the f-stop as desired. This remains constant while the camera adjusts the shutter speed, if necessary, to compensate for changing light. This setting is preferred mainly for outdoor shooting, where the lighting may vary but creamy bokeh is desired behind the subject.

Shutter Priority or Time Value (S or Tv)

When you set the shutter speed in shutter priority, it remains locked in at that setting. The camera will then automatically select the

MISTAKE 13

Shooting 100% in Manual Mode

🚫 DON'T DO IT!

aperture to admit adequate light. For instance, if $\frac{1}{500}$ second is set as the shutter speed, it remains there while the aperture adjusts to the light while tracking subjects in motion. This setting is good for freezing motion or creating motion blur (in flowing water, for instance). It is especially effective when photographing sports, dancing, boat racing, and other activities where fast action plays a role.

Program Mode (P)

Some creative adjustments are also possible when shooting in a camera's program mode. Photographers may use this setting when time is especially critical, such as when documenting live events for photojournalism. Similarly, this setting may be helpful to use when shooting candids at a wedding. Carefully consider available light (*i.e.,* for inside or outside) and set the ISO. Then select P and allow the camera to select the shutter speed and aperture for more critical exposure within a greater ISO range.

Mastering Manual Mode

I find that most of my community education students only want to learn "camera"—not "photography." They simply want to know what button to press on their camera, without understanding the function behind it. Learning the names of the camera dials is like only learning which piano keys are A, B, C, D, E, or F. Just knowing the keys doesn't mean you can sit down and play a tune. The entire skill must be put together and practiced. Rapid manual adjustment of shutter speed and aperture to get a correct exposure must become second nature to a professional photographer. The regimen can be compared to learning how to play a piano—no amount of information will compensate for practice.

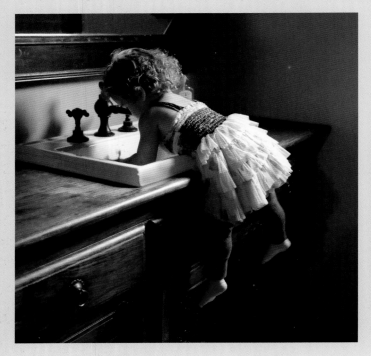

▲ Manual is the preferred setting when you have time to make adjustments for full control of the aperture, shutter speed, and ISO.

◄ **LEFT**—This spontaneous image, titled *Just Sinking*, was captured from the doorway of a dimly lit bathroom. The camera would have over-compensated for the low light, so manual settings had to be made quickly to catch the child hanging on the edge of the sink. This image achieved Merit Print status and hung at the PPA (Professional Photographers of America) national convention.

Auto Mode (Auto)

When set to auto mode, the camera will select all the settings based on its evaluation of the scene (light, speed of subject, and focus). The auto mode is the least professional of all the settings on the dial because it lets the camera make *all* the decisions—and sometimes it makes bad ones. In low light, it may cause the camera to overexpose and deliver dull, hazy results.

Scene Modes

The scene mode settings are found on smaller, consumer-type cameras. They include various automatic shooting modes arranged by subject according to the icon depicted. Typical modes include portrait, landscape, macro, sports, night portrait, and no flash. A professional camera will not have these settings.

Not so fast. Corner-to-corner sharp focus may be right for some images—but not all. One technique that allows a professional image to stand out from the pack is the use of bokeh (when the background looks blurry and produces jewel-like formations from lights behind the subject or sunlight on leaves, etc.).

Demanding Sharp Focus from Corner to Corner

⊘ SOMETIMES OKAY

A Fast Lens for Bokeh

Remarkable bokeh is achieved with the use of a lens that can open to a wide aperture. "Fast glass" (as professionals call this type of lens) allows the subject to stand out sharply, while the background appears blissfully soft. Professional photographers adore bokeh and invest big bucks in quality lenses that can achieve it through wide apertures such as f/1.4, f/1.8, and f/2.8.

A favorite professional lens used to create lovely bokeh is a 70–200mm with an f/2.8 aperture. That's the lens Drake Busath used to create the image to the right. Using wide-open apertures requires practice and a solid understanding of how the selected lens reacts to a subject and its surroundings.

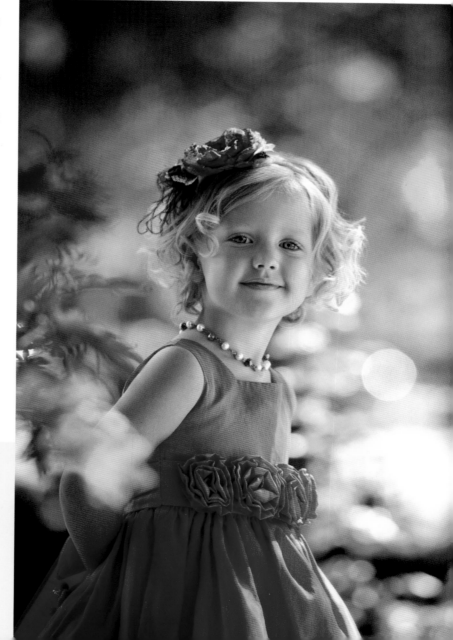

▶ Drake Busath created delicious bokeh for the background of this delightfully lovely child portrait.

▲ Image 1.

▲ Image 2.

▲ Image 3.

▲ Image 4.

Practical Examples

Moving the camera close to this subject (image 1) creates large jewel-like shapes in the background. However, focus to a specific area becomes more critical the closer you get and must be directed to the spot where sharpness is specifically intended. The aperture for image 2 was f/1.6. For image 3, I closed down the aperture to f/2. Image 4 shows the result when the aperture was narrowed all the way to f/16. This allowed both the Christmas pyramid and the tree to be in relative focus. The result is a very "ho-hum" picture without any pizazz.

Things to Know about Bokeh

- Be prepared for an argument on how this Japanese word ("boke," meaning blur) should be pronounced. The *correct* pronunciation is *bo-* (as in bow and arrow) and *-ke* (as in kettle). It is often incorrectly pronounced as bo-KAY.
- Wide apertures are great for getting super-close to a subject in order to get killer bokeh. Wedding photographers love to create strong bokeh behind rings and shoes. Food stylists use bokeh to make certain parts of food stand out with only a hint of other table-related objects in the background. It is important to note that when photographing close to a subject, areas on a different plane will reflect acute differences in focus.

- Move the focus point around to make certain your focus is on the exact point you want to be sharp.
- Backing away from your subject will even out the sharpness between the background and the foreground; bokeh will diminish.
- Distortion may come into play at the sides of your frame.
- Prime lenses (fixed focus) with wide apertures will produce fantastic bokeh.
- Professionals love the versatility a 70–200mm f/2.8 lens provides because it gives a soft bokeh in the background while keeping the subject sharp (and vice versa).

Depending on the Camera's Auto White Balance

Should you rely on your camera's automatic white balance for correct color? Some pros do, some don't. The automatic white balance on professional and semi-professional cameras gets it right most of the time (depending on the camera). However, if the camera gets the color correction *wrong*, it can be tediously time-consuming to repair the image in post-processing—especially if there is no white area in the original image for the RAW editor to take a reading from. As a result, many pros prefer to create a custom white balance.

▲ Use this color and white balance reference gray card set to establish correct color in a shot.

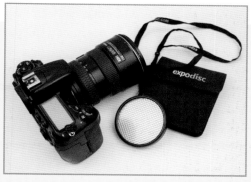

▲ Pre-white balancing can be accomplished with a device affixed over the lens, such as this ExpoDisc.

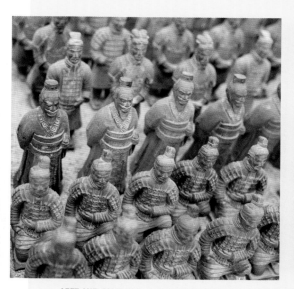

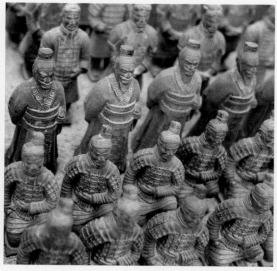

▲ **LEFT AND RIGHT**—If a neutral gray card had been used to pre-white balance prior to the shot (left), the camera would have compensated for the yellowish cast caused by the overhead lighting. Adjusting the color in post-processing was time-consuming since there was no white area to apply the White Balance tool in the RAW editor. In the final image (right), the terracotta warrior replicas exhibit their original clay color.

MISTAKE 16

Shooting JPEGs to Save Card Space

⊘ DON'T DO IT!

This point gets a big NO. If your camera can shot in RAW format, *do it!* Why? The RAW format records *all* the captured image data; the JPEG format takes all that lush information, condenses it, and spits out a CliffsNotes version. If a RAW image is over- or underexposed, you have millions more pixels at your disposal to fix it. Plus, in a RAW post-processing editor you can adjust the white balance, get more detail, and enjoy the benefits of non-destructive editing.

If you are timid about making the leap into RAW, shoot in dual formats (RAW + JPEG). This will ease you into the best way to capture images—and give you the choice to process JPEG if you do not need the extra "boost" that RAW provides. Don't worry about storage space; memory has never been so cheap.

Adobe Camera Raw

The image below shows a restaurant "cave" in Estonia. Processing the RAW file in Adobe Camera Raw not only lightened the photo overall but also helped bring light to specific areas using the Adjustment Brush.

- Open the file in Adobe Camera Raw/Lightroom.
- Lighten the overall exposure with the Exposure slider.
- Select the Adjustment Brush.
- Click in a specific area that needs to be lightened and adjust the brush size.
- Move the Exposure slider to lighten as needed.
- Click "new" and lighten another area.

▼ In Adobe Camera Raw (or Lightroom), the Adjustment Brush can be used to isolate and adjust areas of an image.

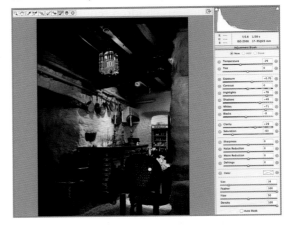

▼ Images this dark have a better chance of being "revived" if originally shot in RAW format.

▼ The RAW file provided enough data to bring out the subtle lighting variations in this scene.

▼ In the JPEG, there was not enough data to lighten the targeted areas, so they look washed out.

Common Issues with ISO and Exposure Settings

🚫 DON'T DO IT!

Avoiding High ISO Settings in Fear of Noise

Noise is the speckled effect that results from shooting in low light conditions; it increases as ISO settings climb. This is not usually a *desired* effect, and some photographers can be excessively noisephobic.

I urge you to keep in mind that the ISO capabilities are improving with each new generation of camera. Newer cameras with high ISO capabilities are the superheroes in this setting; most can be used at 2500 ISO (or higher) with no obvious grain problem.

High ISO settings are helpful for lifestyle photography, which is often performed with natural light inside not-so-bright homes. Capturing rambunctious children requires higher ISOs because of the need for faster shutter speeds. Don't sacrifice a great moment for fear of bumping up the ISO—even if there's a little noise increase. Noise is better than blur. Lifestyle photography is often presented in black & white, where noise may even be welcomed.

🚫 DON'T DO IT!

Seeking Camera Repairs for Exposure Issues

If your camera regularly over- or underexposes images, don't send it out for repair. It's not necessary. Individual cameras can have exposure idiosyncrasies that can be adjusted by the owner. For example, if your camera seems to be consistently overexposing (for your personal taste), the exposure compensation can be moved back from the default 0.0 setting to –0.3. This adjustment remains in effect until you change it.

▼ In my fantasies, I picture this unposed, grainy, storytelling image in *LIFE* magazine–a job I would have loved.

▼ This close-up shows the noise created under not-so-favorable lighting conditions with a camera that did not have very good ISO capability.

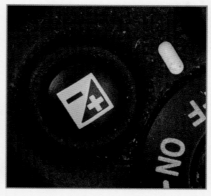
◀ This + and – in black and white triangles is where exposure can be quickly adjusted long term or on the fly.

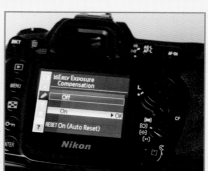
◀ Exposure compensation is also accessible from the menu.

Lighting takes up a large portion of this book because it is photography's most important component. Instead of using a brush, the photographic artist paints with light.

MISTAKE 19

Letting the Camera Set the Exposure

🚫 **DON'T DO IT!**

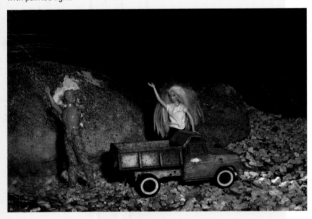

▼ *A Farewell to Arm* is part of a series of Barbie parodies, shot at night with painted light.

▼ The depth is mostly washed out when shot in auto mode because the camera's light meter overcompensated for the diminished light.

Y ikes. Don't count on the camera getting it right for your particular vision in an image. A camera's automatic metering does not always produce the desired results, especially when extremely different light values are within the same frame. The camera says, "I'm so confused! What do you want me to meter—light or dark areas?" When shooting in low light, the camera may overcompensate by providing too much exposure. A camera's exposure system may also fail you when the scene is brighter or darker than middle gray.

Practical Example

Here's a case in point. I was presenting a workshop where a model was posed near filtered window light. The light, though sufficient, wasn't strong. After making several captures and each time checking the back of his camera, one of the attendees went to the window and pulled down the shade, explaining that he was getting too much light. I knew that couldn't have been correct. Although he had recently purchased that $5000+ camera, all the settings were on automatic. The camera's internal metering overexposed to compensate for the low light. The more he darkened the room, the more washed out the image became.

Think Lighting First!

Whether natural or artificial, think lighting first. How do you want it to influence your subject? Will the image be high key (light and bright) or low key (dark and somber)? Does the lighting convey a dark mood or is the image more light-hearted? Light plays a giant role in telling the story. As photographer Cedric advises, "Don't take photographs of subjects, take photographs of the light."

T his is sometimes true. A camera's built-in metering system doesn't function in the same way as a handheld light meter, but the end goal on both devices is to provide information about what's going on with the light.

Know Your Camera

The most important thing is to understand how your camera's metering works. Higher-end cameras offer different types of metering. Manufacturers may apply a variety of names to the various metering functions of their camera models (*e.g.*, partial, evaluative, matrix, center-weighted, or spot). The settings the meter provides are extremely valuable as a starting point. The final exposure level can be adjusted up or down from there.

Practical Example

Professionals like Ted York understand how to get the most from in-camera metering. Of the images to the right, he says, "I used to meter my hand and add 1 stop of exposure to my reading. These days, I make educated guesses initially, then check the histogram. People who do not understand how to use the meter in the camera will get underexposed landscapes, blown-out wedding dresses, etc."

Thinking Handheld Light Meters Are No Longer Needed

🚫 SOMETIMES OKAY

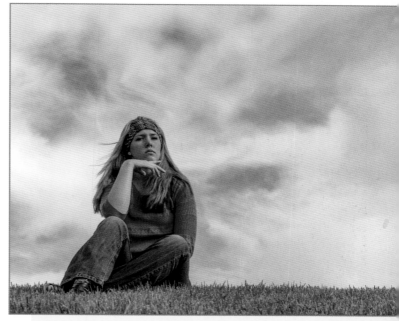

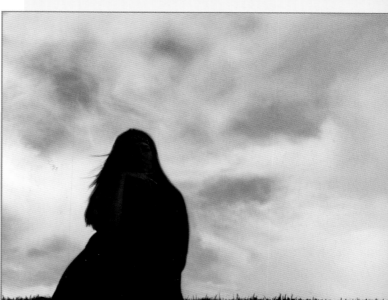

► **TOP AND BOTTOM** – In this photograph created for the stock image market (top), the camera's spot metering was used to pinpoint where correct exposure was wanted – that is, on the girl and grass without figuring in the sky. Without spot metering, the girl became a silhouette (bottom) because the bright sky influenced the exposure.

MISTAKE 21

Avoiding Shoots in the Midday Sun

⊘ SOMETIMES OKAY

▶ **FACING PAGE** – Shannon Sewell expresses how she got really good at shooting in midday. She says, "There are times when harsh light looks amazing in your picture." Practice making great photos with the sun blazing out from behind your subject.

This is true—at least until you learn how to harness light. Most professionals advocate avoiding bright sun by shooting in early morning or late afternoon during the "magic hours." If those times are not available for the session, there are many tactics that can be employed to achieve success—including shooting into the sun! Go for drama and the chance to create a really exceptional image by taking on the "sun challenge." Muster the courage to face it straight on. Set your camera to manual (or at least aperture priority) and spot meter to prevent it from getting confused by the intensity of the light behind the subject. This is one place where a rule can be broken to achieve grand results if you know how to do it!

Shooting in Bright Sun

Shooting in bright sun can be problematic unless you know how to harness it. Harsh shadows fall under the eyes and nose. Creases are accentuated by light falling across the face at an angle—plus frowns and squinty eyes can be caused by the brightness. The camera's built-in flash can wash away shadows caused by the sun but the results may be flat and washed out. The following are some defensive measures that work when shooting at midday:

- Affix a lens hood. Lens hoods are good to use in almost all situations.

- Dial in a lower flash compensation setting to decrease shadows under eyes/nose.
- Have models close their eyes. Snap quickly when you say "open" on the count of three.
- Use a gobo/scrim (large frame with translucent fabric stretched on it) to diffuse the light.
- Don't chuckle, but a person who casts a very large shadow may also work as a sun shield.
- Use a neutral density (ND) filter to cut down on the light coming into your camera.
- Put a hat or sunglasses on your subject.

About Neutral Density (ND) Filters

Don't attempt to get killer bokeh by using a wide-open aperture on a sunny day. It won't work. Present-day cameras have their limits. However, just as we put on sunglasses to keep from squinting, you can use a neutral density (ND) filter to cut the light reaching your camera's sensor.

Don't get confused by all the different ways ND filters can be numbered and adapted for a lens. Some are screw-on models; others are affixed with holders. Different ND values (levels of light-blocking power) are quantified by their optical density or f-stop reduction capability. For instance, the optical density of 0.3 equals 1 stop of light reduction, 0.6 equals an f-stop reduction of 2, and 0.9 reduces the

▼ Use a neutral density filter to cut down on light when a wider aperture is desired for creating nice background bokeh.

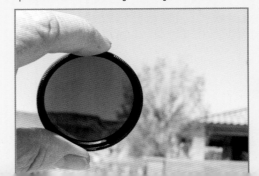

▲ Photographers often fail to notice subtle leaf patterns when shooting under trees. For a tree to be useful, it should not create really dense shade or throw leafy shadow patterns on the model.

▲ Digital capture does not handle extreme variations of light values as well as film did. The resulting aberrations produce yellow-orange "rainbows" where the sun ends and the shade begins.

▲ The sun at 9AM accentuated the creases on my subject's forehead and created dark pockets of shadow over her eyes.

◄ Shade trees are even more useful when they provide blossoming color. Although this is a candid travel photo, notice how the girl is not simply standing in front of a tree with a grin on her face. It's certainly not a run-of-the-mill selfie. The tree here is used as a prop as well as for shade and a gentle rest for her hand to help frame the image.

exposure by 3 stops, and so on. ND filters can also be stacked to create a darker value.

A more versatile (and pricier) version is the all-in-one variable density ND filter that can cost $100–$200 or more, depending on the diameter needed for the specific lens that accommodates it. Beware of the cheapies because they can compromise image quality.

Landscape photographers often use gradient ND filters (half ND, half clear) to balance the exposure between the bright sky and the darker land. The filter is positioned in an adapter on the lens, then adjusted up or down to align the clear/ND transition with the horizon line.

Using a Tree to Shelter from the Sun

Trees can be awesome light blockers when used correctly—but don't consider them catch-all solutions for bright sun. Trees may be hazardous to your images for several reasons:

- Trees may not be where you need them.
- Birds create droppings.
- Nasty leaf patterns may appear on your model's face.
- Chromatic aberrations are caused by dark shadows and bright patches of light in the same spot.
- The shade may be too dark.

Natural Light Purist?

Some photographers specialize in using only natural light on their subjects. Cameras with high ISO capability have made natural light photography more achievable in low light situations. However, it's not the gloomy days but the bright sun that's a killer—especially in areas where there is very little cloud cover. Seattle doesn't get enough sun and Phoenix provides overkill.

Know When It's Time to Turn Off the Sun

Portraits created outdoors can be problematic. Sometimes it is easier to move on to Plan B. This image was captured on the same day as the previous shots in the bright sun. We abandoned the great outdoors and moved inside. The client was provided with a change of clothing more suitable for a studio portrait. It's easer to get a professional-looking photo with controlled lighting.

Battery Packs and Speedlights

Today's mobile battery packs for lighting make it easy to go out on location and have plenty of light on a subject—wherever you want it. A collection of banked speedlights (small flash units) will also work to boost the light levels or add fill on darkly lit subjects.

MISTAKE 22

Boosting Exposure for Brighter LCD Previews

⊘ DON'T DO IT!

That's absurd! Exposing on the bright side puts you in danger of wiping out pixels, which is more destructive than shooting "dark." "Blown out" (extremely overexposed) areas of an image cannot be restored satisfactorily in postproduction. On the other hand, there may be some pixel information in underexposed areas that can be retrieved in your RAW image processing. Aim to expose correctly, but if a slip is made, it's better to "go over to the dark side."

▼ **LEFT** – A quick adjustment of both the shutter speed and aperture brought correct exposure to this image.

▼ **RIGHT** – If not using a meter, pull off a shot (here, it's clearly overexposed) and work your way to a correct exposure from there by either narrowing the aperture and/or increasing the shutter speed to bring the light into submission.

▶ When working on a RAW image, the histogram on the upper right side of Photoshop has a small box in each upper corner (see the red arrows). These boxes show where dark and light areas are "clipped" in the image.

No! Softer shadows are not created by moving the lighting equipment farther away from your subject. In fact, the opposite is true! The larger and closer the light source (relative to the subject) the softer the shadows will be. While sun is large, it is very far away and creates harsh shadows. On overcast days, clouds act like a giant diffuser. The same principle works with modified lights in the studio that have cloth coverings to coax the light into being soft (hence the name "softbox").

Distancing the Light Source for Softer Shadows

⊘ **DON'T DO IT!**

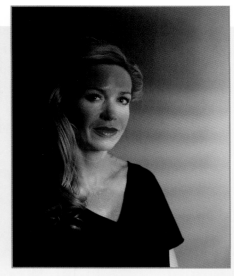

◄ **LEFT** – This film noir project demonstrates how the shadows get harsher as the light gets farther away from a subject.

◄ **RIGHT** – This unretouched image shows how the shadows soften when the light is moved closer to a subject.

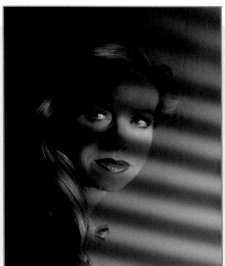

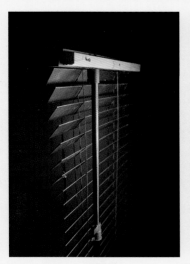

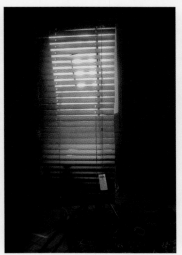

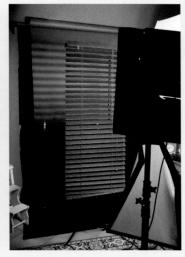

▲ **LEFT, RIGHT, AND CENTER** – This film noir setup took very little time to assemble. Screw a set of blinds to a small strip of 2x2-inch wood. Drill a 3/8-inch hole in the wood three-quarters of the distance along the strip to allow it to fit onto a background stand but not cause a vertical shadow in the middle (left). Remove the modifying fabric from a softbox and place the box where it provides the intensity and type of shadow desired (center). When the blinds are closer to the light source, the shadow will be softer. Adjust the distance between all components until the desired shadows are created (right). Use seamless background paper (not fabric) that is absolutely flat to provide shadows that don't "warp."

MISTAKES 24 AND 25

Common Concerns with Strobes, Continuous Light, and Built-In Flash

portrait work. With these units, the lighting you see as you set up the session is what you get in the camera. Continuous lighting is especially friendly for working with individuals who are prone to seizures.

🚫 DON'T DO IT!

Using Built-In Flash to Light a Dark Subject

A professional doesn't use the camera's pop-up flash to light a subject—in fact, most high-end cameras don't even have built-in flash. On-camera flash puts an unpleasant catchlight directly in the middle of the eye and creates a very flat looking image. Small, off-camera flash units *can* be used effectively with practice. Even though speedlights seem like the "big brothers" of pop-up flash, they far more flexible and can provide professional results (again, when used correctly).

🚫 DON'T DO IT!

Assuming Strobes Are the Only Pro Option

Unless your subjects are darting around the studio, cool-running, continuous, daylight-balanced fluorescent lighting may be a good choice. It has an easier learning curve and is now preferred by many professionals for

◄▼ Good portraits are "sculpted" through use of shadows (below). This off-camera lighting also produces nice catchlights in the eyes on the main-light side of the subject. In contrast (left), the on-camera pop up flash produces flat lighting and puts a small, circular catchlight in the middle of the eye.

◄▼ The mother's hand shows movement here because a slow shutter speed was used with this fluorescent lighting, which is not as strong as strobe lighting. However, cameras now handle higher ISOs without much noise. Three Westcott cold continuous lights are used here: 1) main light, 2) hair light, 3) light behind the fake window setup.

In today's market, client excitement swirls around shooting in enchanting locations. Photographing on location requires planning—*lots* of planning. You have to know how your "location" will look at various times of day and in different seasons.

"Okay," you might ask, "then how about just switching out my studio backgrounds?" Here's the answer: Even expensive painted murals or green screens do not impress your clients as much as seeing and feeling an actual location. Clients appreciate the effort you make to put creative thought into a shoot that has "atmosphere." Would you expect to pay as much for a sandwich out of the automat as you would for the same sandwich at a cool bistro with lots of ambiance?

Create an album to show location options and the best times for a session (because the lighting and your shooting direction will change with the time of day). Scout areas in your community and not-so-distant environs for ideal shooting locales. Studio photographers who go out on location usually charge extra. If you don't have a studio, play up the excitement of location shots even more!

Planning Is Critical

Long before the day of your planned session, run the entire sequence through your mind. If on location, where will the client sit or stand? Where will the sun be at the time of the shoot? Do you have all your gear, including backup batteries, appropriate lenses, lighting, photo cards, and an extra camera? Is it all charged and ready to go? If necessary, draw sketches of what you have in mind for posing. Be sure to stake out the location ahead of time (as close to the actual session appointment as possible).

Portrait planning often starts with decisions about what will appear behind the subjects—whether on location or in the studio. Here are some common mistakes to avoid.

MISTAKE 26

Booking Too Many Studio Sessions

🚫 **DON'T DO IT!**

▼ How could any studio shot be quite as memorable as Jamie Coonts's capture amidst this dramatic corridor of fall foliage? There may be only a one-week window of opportunity to catch autumn leaves as awesome as these. (And you don't want to schedule a session only to find that winter's swift wind blew all the colorful leaves away.) The visual is, of course, thrilling—but memories connected with the entire experience will create pleasant recollections until it's time for another family shoot next year!

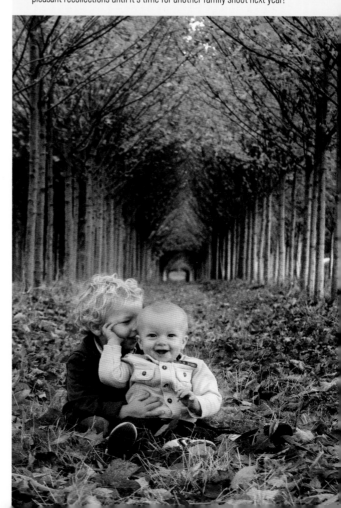

MISTAKES 27 AND 28

Common Issues with Backdrops

Putting the Subject 2+ Feet from the Background to Avoid Shadows

This is one of those old-school techniques that is still worth heeding for formal head shots where obvious shadows are not wanted. However, in today's creative market, this is a rule you can sometimes break. If you do it thoughtfully, the shadow will become an integral part of the image—and one that also goes against the norm.

Using Huge Backgrounds

Tradition says that an adequate studio background should be large enough to cover the backs of a small group and then extend out under their feet (usually 10x20 feet or larger). That's nice, but it's not always necessary. If you're doing a head shot or photographing a small dog, the background only needs to cover the immediate area behind the subject. Be on the lookout for random backgrounds. At the MGM Grand in Las Vegas (facing page, top) we found a cool patch of "diamond tread" sheet metal behind a huge dumpster.

▼ Shadows behind headshots were once a big no-no. Now it's okay to play with light and use dark areas to create mood. Likewise, it's traditional to have "space" in front of the subject so they have "room to move." The dubious expression on this woman's face fits with her unusual placement in the frame.

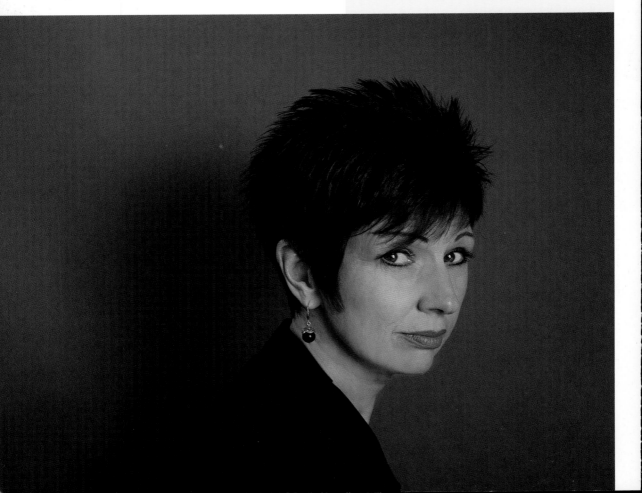

▲ This eye-catching background was found in the dumpster area at the side of the MGM Grand in Las Vegas.

▲ ► It didn't take much of a background to capture this pooch portrait. As seen in the pull-back shot, the background is a piece of foam board with some crushed velvet wrapped around it and taped to the other side. A sheet of white board was used to bounce light from the softbox main light.

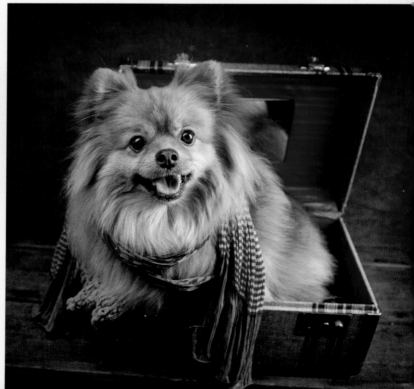

MISTAKE 29

Shooting on Brightly Colored Backdrops

⊘ SOMETIMES OKAY

▼ It would be risky to photograph a fair-skinned baby crawling on this green floor, not because of splinters, but because the green vinyl will make him look a little sick around the gills.

▼ The woman's bright turquoise blouse reflects a green cast on her neck.

Just because backdrop companies sell all kinds of flooring options in bright colors, it doesn't mean a baby will look good crawling on it.

Unnatural colors will bounce back onto the baby—and the resulting color cast will be especially obvious if the child has a light complexion or is wearing light-colored clothing. The same thing happens when you use lush green grass, colorful walls, or vibrant backgrounds. Paint a studio shooting area with white paint to avoid unwanted color casts on your subjects.

Where fur is concerned, however, don't worry! Bright colors are great for pets—and the background you use doesn't have to be very wide.

Resources for Backdrops and Floor Drops

- ■ B&H Photo—bhphotovideo.com
- ■ Backdrop Outlet—backdropoutlet.com
- ■ Denny Manufacturing Co., Inc.— dennymfg.com
- ■ Etsy—etsy.com
- ■ Lemon Drop Backdrops— lemondropshop.com
- ■ Savage—savageuniversal.com

▲ Check out Savage's splendiferous array of seamless background paper. Included are two chroma-key colors (Tech Green and Studio Blue), used for easy background swapping.

▶ **FACING PAGE**—Bright backgrounds work great for pets! (Although this one seems to be asking, "Do you think this scarf makes me look fat?")

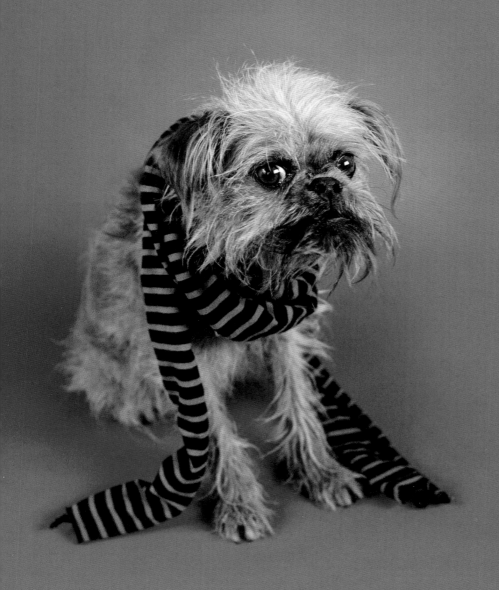

MISTAKES 30 AND 31

Common Issues with Outdoor Backgrounds

The shot below, captured in the beautiful gardens of the Busath Studio, would not have been as successful if the group was three feet to the side where tree trunks would have protruded from their heads. The rock "steps" were created at different levels—an essential ingredient for posing family portraits.

⊘ DON'T DO IT!

Using Sky to Frame the Heads of an Outdoor Group

Another background faux pas is incorrect placement of a horizon. Bring along a short stepladder for group shots. In the images on the facing page, you can see how Jennifer Bacher stood on a ladder to shoot from above the group (top photo). That's how she was able to eliminate the distracting horizon line (bottom photo).

⊘ SOMETIMES OKAY

Using a Grove of Trees to Provide a Lush Background Behind a Family

Be careful. Always watch what is going on in the background. Trees can provide a great backdrop but often have pesky elements that seem to pop out of your subjects' heads. Trunks and branches can become a huge post-processing nightmare for the photographer who only sees the green "leafery" and doesn't bring the entire tree into the equation.

▼ Drake Busath carefully positioned this family against the lush background to ensure that no pesky branches or tree trunks distracted the viewer from their smiling faces.

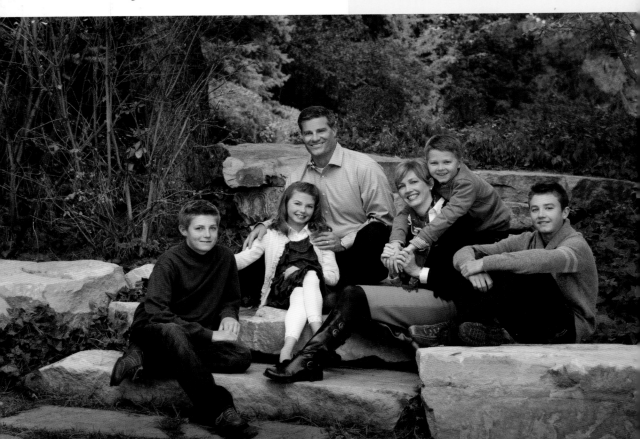

▲ The photographer brought along a ladder to eliminate the bright sky from the shot and create a smooth background, uninterrupted by the horizon. Photo by Jennifer Bacher.

▶ The pose and lighting is nice, but the horizon cutting near and through their heads is a bit distracting. Photo by Jennifer Bacher.

Elevating the Camera Over a Group Ensures:

- Individual faces will show more.
- The horizon doesn't cut through the heads.
- A more pleasant composition can be arranged.
- The tonal range is easier to manage because a bright sky is not included.

MISTAKE 32

Shooting on White Backgrounds

🚫 SOMETIMES OKAY

Cool but tricky. Popping subjects out from a white background is a great idea, but not all photographers have the skills needed to pull it off correctly. White is a tricky color to include in a photo. Bridal dresses can get "blown out," losing pixels and depth. Also, white-on-white images can present their own set of challenges. Without correct exposure and directional lighting, whites can appear as flat, burned-out sections of the photo. White is difficult for the camera to understand because it prefers to register neutral gray tones.

Outdoors

Of the top image on this page, Drake Busath says, "In very flatly lit situations like this one, I like to use an off-camera flash. This adds some shading and texture to the whites, which otherwise can lose dimension. For this group in the snow, I set up a softbox to the right of the group, almost at 90 degrees from the camera axis. The exposure was set for the ambient light level and then the strobe was set about equal to the ambient light level. I often see photographers make the mistake of using too much flash, creating an artificial look. Flash outdoors should be just a light touch."

In the Studio

Ted York captured white beautifully in the bottom image on this page. Ted advises, "The whole scenario needs to figure in light as it relates to the background, the angle of the light on the clothing, and—of course—correct exposure to avoid blowing out certain areas. The exposure needs to be spot-on to pick up shadow detail in white clothing." Regarding groups, Ted says, "When I photograph families in the studio, I often break them down into groups. Each group is photographed separately, then the images are stitched together in Photoshop. A simple background is one of the keys to accomplishing this easily, without any repeating objects or patterns in the finished image. It is important that the backdrop be lit as evenly as possible and that the white clothing is not the same in brightness as the white background behind them. If the skin is properly lit, this process is not usually a problem."

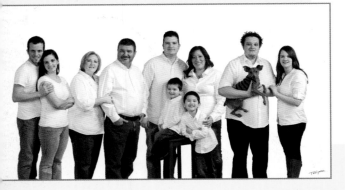

◄ Portraits by Drake Busath (top) and Ted York (bottom).

True. Body parts of dark complexioned subjects, or subjects in dark clothing, do tend to disappear when they are photographed against black backgrounds. While this makes some photographers shy away from black backgrounds, black can be very dramatic—if it is handled correctly. Simply adding a hair light above the subject throws highlights onto dark hair, allowing for tonal separation.

MISTAKE 33
Shooting on Black Backgrounds

⊘ SOMETIMES OKAY

◄▼ This teen's dark complexion and hair color would have been lost against the dark background if a hairlight had not provided luminance from above. In this case, I used a daylight-balanced hairlight by F.J. Westcott positioned on a boom arm above the subject.

Try Gray Instead

A more do-able alternative for black is gray. Savage offers a variety of seamless background papers—and gray must be popular because there are no less than fifteen shades available! You can visit their web site (savageuniversal.com) to find an authorized retailer.

▼ Experiment with subtle lighting from different angles. Rim lighting was the key to success for this maternity shot.

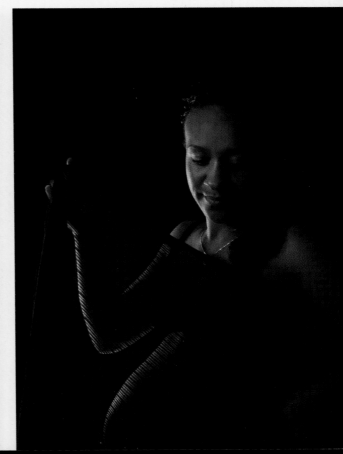

MISTAKE 34

Eliminating the Foreground

⊘ **DON'T DO IT!**

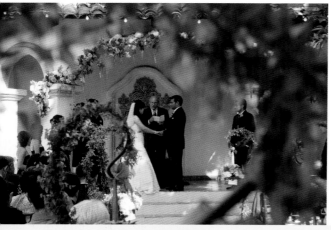

Why do that? It's a natural instinct to avoid an object that seems to be "in the way" of the intended subject. While traveling, I see tourists lean over the top of a beautiful fence or hold their camera over the side of an ornate bridge just to get it out of the way of the shot. But why not *include* that interesting object as part of the composition? Sometimes it completes the story of the scene and establishes where the viewer is standing. What's more, that snippet of fence, bridge rail, or rock very often adds interest or even drama to a photo. It can also provide a framing device to pull everything together.

> 66 That snippet of fence, bridge rail, or rock often adds interest or even drama. 99

◀ **TOP LEFT** – Scott Nelson included foliage in the foreground to add interest to this wedding capture.

◀ **CENTER LEFT** – Most tourists hop off this Norwegian train to snap a photo of the bright-red locomotive before continuing on to the fjords. This photo of snow-covered bikes in front of the train creates a more interesting story.

◀ **BOTTOM LEFT** – Knowing that my grandmother walked along this estuary in Trondheim, Norway, gives more meaning to the walkway where I followed in her imaginary footsteps.

▼ **BELOW** – Another ho-hum boat harbor shot? Liven it up by adding color to the foreground.

Reducing the Perspective

⊘ DON'T DO IT!

D on't flatten your scene—use the background and foreground to help you tell the story!

Carl Caylor likes to call it "milk." He asks, "What is at the top of your grocery shopping list?" The answer is usually dairy products. But where do they put dairy products in the supermarket? They make you walk all the way through the store to get to the dairy section. A photograph can benefit from the same strategy by encouraging the viewer to meander through an image in order to reach something important in the background.

Renaissance painters used the same device. Their aim was to provide a bit of background in the composition to allow the picture to tell a story. Test it. The eye is "happier" when it can roam through the image and not have to stay affixed to the middle.

▶ *In Your Dreams* plays the foreground against the background to tell a story.

▼ Use photo tricks to place emphasis on certain parts of a photo.

MISTAKE 36

Shooting on Railroad Tracks

🚫 DON'T DO IT!

Through Operation Lifesaver, Juli Bonell campaigns against the illegal and dangerous practice of photographing on train tracks. Her blog (bonellphotography.blogspot.com) also provides guidance for discussing this kind of location with clients who request it. She also presents as a lot of other hard facts about the potential risks of conducting photo sessions on the tracks.

Don't go there—literally. To photographers, railroad tracks are like the mythical figure Lorelei, whose song lured sailors along the Rhine to crash and die on her rock. This practice is not only illegal (carrying potential jail time and fines up to $10,000), it has led to the deaths of both photographers and clients. A quick Google search turns up several tragic accounts.

❝ This practice is not only illegal, it has led to the deaths of both photographers and clients. ❞

▼ Like many photographers, Juli Bonell used to photograph sessions on the railroad tracks in her area. After learning about the dangers and potential legal issues involved, she now avoids these scenes—and advises other photographers not to take the risk, either.

Broadly speaking, photographers' posing and shooting practices are as varied as the languages they speak. However, there are some useful pointers that are largely universal and can make the session run more smoothly, facilitate post-processing, and provide superior results.

MISTAKE 37

Thinking Technical Ability Outweighs Creativity

⊘ DON'T DO IT!

A re you kidding? Joel Grimes, who is recognized for his dramatic composite images, says, "It is vital to learn the technical side of photography, but creative passion will outshine technical ability when it comes to getting hired. It all comes down to the fact that I have a passion to create. It is all-consuming. Having access to tools like a camera and programs like Photoshop gives me so many options that if I lived ten lifetimes I would never run out of ideas to create. One of the biggest challenges for me is to set enough time aside to do self-assignments—I try to do fifty a year."

66 Having access to tools like a camera and Photoshop gives me so many options that if I lived ten lifetimes I would never run out of ideas. 99

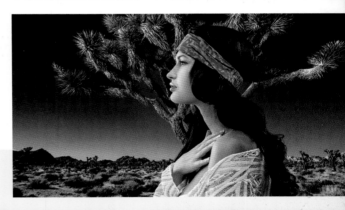

▼ ► Joel Grimes creates exquisite stories with his beautifully executed composite images.

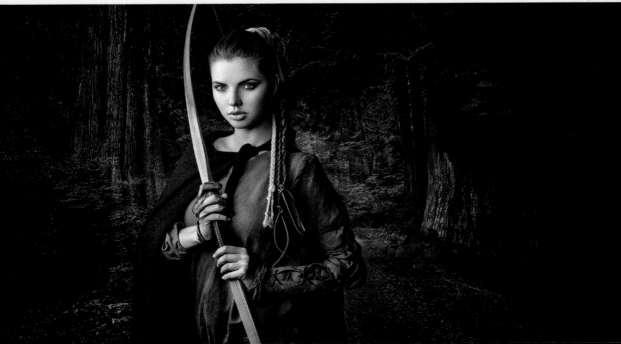

MISTAKE 38

Thinking You Must Have an Assistant

⊘ SOMETIMES OKAY

Does a professional always work with an assistant on a photo shoot? Not always. In fact, some high-end professionals prefer to work alone. Even if you want to use a reflector, there are some options. For example, you could have the subject hold a reflector. If at a slight angle to the camera, this helps tilt the shoulders at an informal angle. (However, this pose is not suitable for everyone, so do some experimenting first.)

▲ A wider view from this session shows how the subject's arms are extended to hold a silver reflector.

◄ If the subject is holding a reflector, remind them to continue to sit up straight.

Positioning a Reflector without an Assistant

- Have the model/subject hold the reflector.
- Put the reflector on a light stand.
- Have a parent or bystander assist (if they will not get in the way).

Think posing stools and tables are photographic dinosaurs? Nope. Although they are not as popular with younger photographers, there is still a place for posing stools in today's market—as long as formal poses are a part of your service. "Hipper" photographers may scoff, but old-school shooters still find posing stools and posing tables to be an essential part of their portrait business. They are especially useful for real estate headshots, engagement photos, and location work.

Posing Stools

Because he brought along his portable posing stools to the wedding, Clay Blackmore was

MISTAKE 39

Never Using Posing Stools and Tables

⊘ DON'T DO IT!

able to place the bride and groom (below) exactly where he wanted them for this lovely portrait. Seated comfortably, the pair relaxed and enjoyed a few moments staring into each other's eyes. Having the posing stools handy

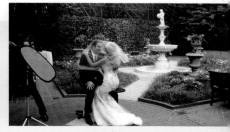

▼ ► Portable posing stools helped Clay Blackmore quickly position the couple for a perfect romantic shot.

provided flexible posing options, eliminated the need to spend time searching for an appropriate place to sit, and helped keep the couple's wedding attire clean.

Posing Tables

Perhaps less used is the posing table, as shown in the top-left photo at the Blackmore & Co. studio. Nevertheless, the pose is classic—and you can see why the table should be seriously considered as a posing tool.

Ever played "air guitar?" When there's no table available, I ask some clients to play "air posing table" by pretending to rest their arms on an imaginary platform. It really works to help relax the client and put the upper torso in a great position—as long as they don't hunch over too much. So many clients don't have a clue what to do with their arms and hands, and this helps solve the problem!

◄ **TOP LEFT**—A client posed at a table in Clay Blackmore's studio.

◄▼ **LEFT AND BELOW**—Who would guess this client is not resting her arms on something? The "air posing table" came to the rescue by giving this client something to do with her arms.

Although free-form groupings are trendy (and a scattering of subjects does make for a pleasant image), it doesn't mean that formal groups can't have a little structure. The formal pyramid configuration used by Renaissance painters is still practical in today's market. In the family portraits shown here, the stable base helps portray solid family unity.

Drake Busath's rule of thumb for head placement in a group is to eliminate "rows and columns" of heads. He says, "It helps me to start with chairs of varied heights, but in the end it always requires me to analyze the head arrangement and raise or lower heads on the fly to break up even lines. I'm also constantly asking someone to lean left or right to avoid 'stacking' heads in vertical lines. The end result is often a series of triangles. However, for an overall group shape, I try to avoid the sharp angles of a triangle. Instead, I build oval or circular lines inside a group by curving the arms. I feel that circular shapes convey more love in a group—and isn't it all about love?"

Skipping Formal Poses for Groups

⊘ SOMETIMES OKAY

▲ **ABOVE** – Renaissance painters knew the power of a triangular configuration.

▶ **TOP RIGHT** – There is a lot of stability and unity portrayed in this family pyramid configuration. Photo by Drake Busath.

▶ **BOTTOM RIGHT** – In this image by Drake Busath, there are two triangles (one pointing up and one pointing down), but the overall shape is a circle.

MISTAKE 41

Not Chatting During a Session

⊘ DON'T DO IT!

Sample Dialogue Suggestions

- So, how long have you been dating? *(For a mature couple)*
- Don't you dare smile! *(Click.)* Awesome!
- That color looks great on you. *(Click.)* Good job!
- Tell me about your boyfriend. *(For young kids)*
- No boyfriend? Are you sure?
- *(Click.)* Outstanding.
- *(Click.)* Perrr-fect!

Some photographers think they should avoid distracting the model with idle chitchat during a photo session. Pshaw! So untrue!

As a portrait photography teacher, one of my most difficult tasks has been getting students to carry on an audible, continuous dialog during their practice shoots. I inform them that successful photographer "superheroes" never shut up while they are working with their clients. They are showmen—performers. If you are saying, "That's not me," count on not achieving your potential.

Clients like being entertained and praised for doing a good job while posing. "Good job," "Beautiful," and "Very nice" are all simple—but effective—comments you can make.

Above all, don't mumble from behind the camera. At the very minimum, issue nonsensical noises. Sing or dance. Humor is such a crowd-pleaser. Have a personal collection of jokes and phrases that work to bring smiles and relax clients. It doesn't matter how many times you use a joke—as long as the audience rotates. Use your most successful "material" over and over. Milk it.

Ongoing conversation may not seem important, but it is actually a huge asset worth cultivating. Silence is a killer; chatter your way through each engaging photo session!

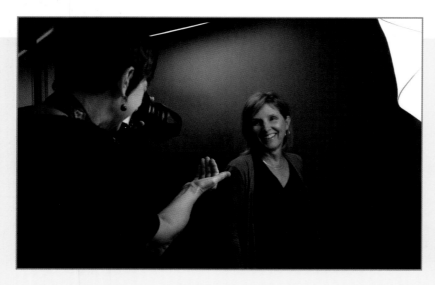

◄ Keep up a friendly dialogue throughout your session with a client. It helps them relax and results in better images.

Common Camera-Care Errors

🚫 DON'T DO IT!

Placing the Camera on Its Backside to Change Lenses

Naughty, naughty! With the lens cavity facing upward, dust and debris could fall onto the sensor and cause nasty spots on your images. (And it's a pesky task to clean sensor dust spots from images.) The same goes for changing lenses from the trunk of a car while on location. Also, don't make the mistake of leaving the camera *on* while changing lenses; static electricity will suck in debris.

🚫 DON'T DO IT!

Setting Down Your Camera Wherever It's Easy to Grab

Don't get into the bad habit of simply setting your camera down wherever seems handy. It's nice to be able pick it up and put it down quickly during a shoot, but you shouldn't put your camera in harm's way by allowing the strap to dangle off a table. Also, shove it far away from the edge. Even a tumble off a chair can cause enough damage to require expensive repairs to the lens or body. Don't discount passing pets that may mistake the strap for an enticing tug toy.

Likewise, care should be given to protecting your lenses during shoots. Get in the habit of replacing the lens cap as soon as you are done using the lens. Always keep a cap in the same place for ready access when you are shutting down the session (a pocket is a good holding place).

🚫 DON'T DO IT!

Keeping the Strap Attached to the Camera

There is a good reason to remove the strap— but it's not to make you look like a hotshot photographer. In a studio setting, cameras are often hastily set on stools or ledges (anywhere handy) while addressing a need to adjust something in the shot. A strap dangling from any kind of ledge is worse than no strap at all.

The most troublesome thing about a strap in the studio is that it always seems to find its way in front of the viewfinder or lens!

▶ The correct position for changing a lens.

▶ Get in the habit of placing the strap on top of the camera instead of letting it hang.

▶ In a studio, the strap can get in the way and may pull a camera to the floor. Consider removing it.

MISTAKE 45

Composing with the LCD Screen

 DON'T DO IT!

Advantages of Composing Through the Viewfinder

- Bright sun does not affect the photographer's ability to see the image.
- Photos can be more accurately composed.
- Focus points can be set on vital areas, such as the eyes (this feature might not function when the LCD screen is on).
- Read aperture, shutter speed, and ISO settings, etc.

Don't even debate this one. Even if live view is available on your camera, you should use the viewfinder to compose your images. The viewfinder is a camera's command center. It displays a wealth of information regarding focus, exposure, shutter speed, aperture, etc.—all in one handy place for easy viewing and within fingertip reach for changing. More importantly, the entire image is much easier to sum up in a tiny viewfinder.

The habit of checking the back of the camera also slows down the shooting process and restricts the opportunity to pick up on details that might go unnoticed by viewing the LCD screen. It is also best to turn off the LCD screen's auto-replay capability, as some important camera features will not function when the screen is lit.

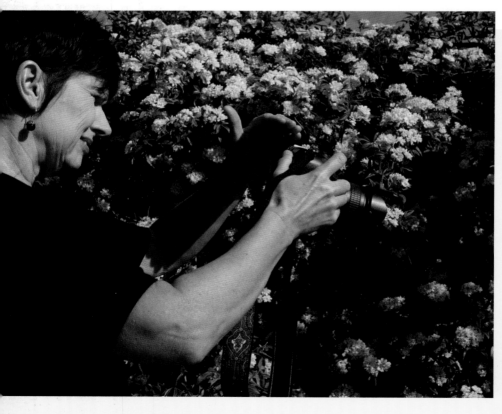

◄ Even if live view is available on your camera, don't rely on it for composing a photograph.

hat's foolish. Don't take chances with camera shake—it can ruin an image. Camera blur is not fixable in postproduction—even though there are new features in Photoshop that attempt to address the issue. A true professional gets in the habit of cradling one hand securely under the lens for support, leaving the other free to adjust the buttons and dials.

MISTAKE 46

Supporting the Camera Improperly When Handholding

🚫 **DON'T DO IT!**

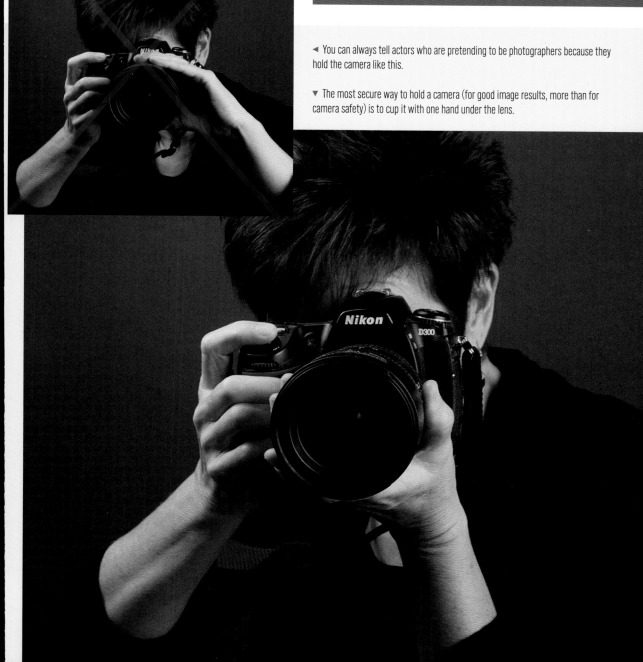

◄ You can always tell actors who are pretending to be photographers because they hold the camera like this.

▼ The most secure way to hold a camera (for good image results, more than for camera safety) is to cup it with one hand under the lens.

MISTAKE 47

Letting Clients Pick Their Own Outfits

🚫 DON'T DO IT!

D o you allow the client to pick whatever wardrobe options feel most comfortable? Bad idea. For the most part, clients do not know what looks best for the camera.

To ensure success, conduct a wardrobe consultation prior to the photo shoot. Specif-ically, planning what the client will wear can prevent the need to reschedule your session.

If time allows, have the client bring a few options for you to pick from. However, a teen-ager may want too many different outfits for their senior portrait, so your photo contract should specify how many changes are allowed per session.

> **66 Planning what the client will wear can prevent the need to reschedule your session. 99**

▼ Provide discreet suggestions about what will look best in a photo—especially for a formal portrait.

▼ The client's choice of wardrobe (shown here) was replaced with offerings from the "studio closet," which required an additional session.

MISTAKE 48

Using Only "Safe" Clothing Colors

🚫 **DON'T DO IT!**

▼ A key to the success of this colorful family photo is its white background. It would not have worked well against a backdrop of fall foliage (unless you were going for a *Where's Waldo?* type of puzzle photo). The folks in this image obviously color-coordinated their wardrobe choices. The separate family groups were photographed in the studio, then stitched together in Photoshop. Photo by Drake Busath.

Safe clothing colors for a family group shot are khaki and white. So *boring!* Your family group may have definite clothing choices in mind, but hopefully they will be open to your suggestions and acknowledge that you know—from experience—what will work best.

Don't be afraid to step into the role of the assertive professional by expressing what you know provides good results. Plan the clothing choices diligently to avoid being surprised by the maverick who didn't get the memo and shows up in his red-and-white numbered football jersey.

As part of Busath Photography's clothing consultation, they have created a selection of color palettes to help their clients coordinate clothing. Each palette shows three or four swatches that work together—along with sample photographs of families dressed in those colors.

They also encourage families to avoid strongly patterned fabrics and go for more solid pieces, and to stay away from mixing darks and lights in the same image. Despite a recent trend to incorporate and accentuate pattern, the Busath professionals feel that portraits will stand the test of time better when clothing does not compete for the viewer's attention.

MISTAKE 49

Fixing Stray Hairs in Postproduction

🚫 SOMETIMES OKAY

Photoshop Tools for Removing Stray Hairs and Blemishes

- **Spot Healing Brush**—Make the brush size a little wider/larger than the hair or spot. Click and drag along the hair.
- **Healing Brush**—Similar to the Spot Healing Brush. Experiment with both.
- **Patch Tool**—Set the tool to Content Aware. Circle the blemish and drag to a "clear" area.
- **Clone Stamp**—Hold Alt/Opt to sample a area and use that sample to "cover" another area.

Of course you should fix stray hairs—but instead of relying on postproduction, try to get it right during the session. Pay close attention to everything that is going on in the frame while looking through the viewfinder. As needed, walk up close to the model and ask permission to make last-minute adjustments (like smoothing her hair).

In case of oversight or issues that can't be corrected through an adjustment before shooting, there are tools in Photoshop and Lightroom that do a good job with taming stray hairs. Also, keep in mind that the stray-hair situation in the image may be improved by *adding* hair with the Clone Stamp tool, rather than trying to remove it.

▼ Stray hairs, like the ones over her ear, may not be noticed until they show up in the portrait.

▼ Although most stray hairs are easy to remove in post-processing, it takes time that could have been avoided by checking for them during the session.

▼ You can also go the other way by *adding* hair to fill in the void (seen here in the area on the upper ear).

Close, but wrong. The general rule for headshots and close portraits is to focus on the *eyes*. Use the Focus Point Selector (Sensor Selector) dial to move the focus point inside your viewfinder and place the sharpness exactly where you want it. (*Note:* Often, if the LCD panel is lit, these focus points cannot be accessed.)

◄ Move the Focus Point Selector to exactly where you want your image to be the sharpest.

Two Methods for Sharp, Accurate Focus

1. **Focus and Recompose.** While looking in the viewfinder, find the Point Selection setting and move the dial to set the point where you want the main focus to be. Hold the shutter release partially down to activate the focus. Continue to hold while moving the camera back to set the entire composition the way you want it. Follow through with the click.

2. **Move the Focus Point.** Use a camera setting that provides a movable focus point. Look in the viewfinder. Move the focus point dial around to land on the area you want to be the sharpest. This process takes longer to accomplish than the "focus and recompose" approach, but it may also provide the sharpest results—and in a close-up shot, the focus on a specific part of the face (usually the eyes) is critical.

► **TOP RIGHT** – While looking in the viewfinder, use the Multi-Selector (Nikon) to move the single small focus point around until it directly targets the eyes.

► **BOTTOM RIGHT** – When using a wide aperture to create bokeh in the background, care must be taken to fix the selective focus exactly where you want it. Here, the focus strayed to the hand.

Focusing on the Middle of the Face

🚫 **DON'T DO IT!**

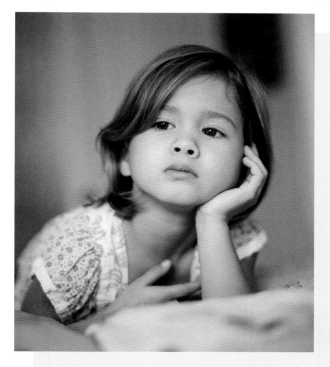

MISTAKES 51 AND 52

Bypassing Creative Opportunities

DON'T DO IT!

Always Scrapping Blurry Images

Not so fast. There are times when blur can be creative. However, you have to know the difference between "out of focus" and "blurred." Photographers who shoot stock are constantly on the lookout for photo ops. Because this market is flooded with millions of creative images, it's a challenge to create work that is fresh—and sometimes creative blurring adds that intriguing new perspective.

DON'T DO IT!

Skipping Creative Wedding Shots to Save Time

Don't hide your creativity, even when time is of the essence. Clients notice ingenuity. They say to their friends, "Look how cool this is." Word gets around and that's how you get new wedding bookings. Be sure to let the couple know that you will be asking them to cooperate with you on creating an album that stands out from the rest!

◄ **LEFT** – This blurred, rainy street scene in Siena, Italy, gets my vote for being an absolute winner! Photo by Drake Busath.

▼ **TOP RIGHT** – A blurred image may be just the unique type of "travel concept" a creative art director is searching for. A man pulling a suitcase was captured from the other side of textured glass at the Seattle airport.

▼ **BOTTOM RIGHT** – Scott Nelson keeps a sharp lookout for creative wedding images that makes the viewer say, "Wow."

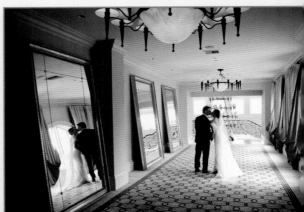

For maximum impact, many photographers think you have to position the camera directly in front of the subject. That's commonplace, not creative. Creativity dictates that

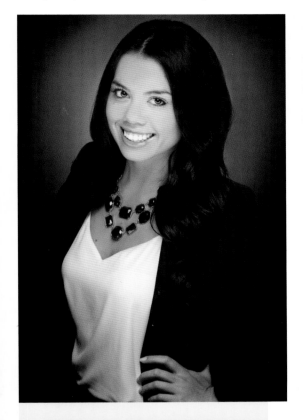

MISTAKE 53

Putting the Camera Right in Front of the Subject

🚫 **DON'T DO IT!**

you do more than photograph from a standing position dead center in front of your subject. Often, that "alternate" camera angle turns out to be the keeper. (When a friend returned from a costly workshop, I asked her what she had learned. Without hesitation, she said, "I learned to move around my subject and shoot from different angles.") However, keep in mind that there are trade-offs. In a close portrait, an upward angle (camera and lighting) will help decrease lines in the face—but too much lighting from below can make someone look ghoulish.

Practical Example: Corporate Headshots

Notice how Jim Garner's corporate and professional images (left) are shot with the camera positioned slightly above the client. It gives them a fresh, vibrant look. To create these, Jim stands on a step stool directly in front of his subject. He has them point their feet to the side and turn from the hips to face him. His clients may cross their arms in various ways or put their hands on their hips to create a more flattering angle. This simple change makes a huge difference!

◄ Jim Garner makes it a practice to elevate his camera slightly above the client.

MISTAKE 54

Failing to Exlpore Different Angles

🚫 **DON'T DO IT!**

Unconventional perspectives create drama. The ads in fashion magazines illustrate this point. A slightly upward, full-body angle will make a man look more masculine. Conversely, shooting down on a woman will most likely produce more pleasing/slimming results. A downward angle also lessens imperfect teeth and crooked noses. If on location, think ahead to bring a small step stool along to the shoot. Didn't bring one along? Throw propriety aside and hop up on a nearby (but sturdy) chair or table.

But take care; although an image shot from below with the camera angled up to the model is certainly doable, it can be risky—especially for women. (For men, it just might turn out gross unless you put the nose hair trimmer to work.) JuliAnne Jonker says, "This is an important point to make because I really *love* to shoot up the nose." In her image below, notice how the upward tilt of the head elongates the neck and creates an elegant profile. Jonker is the consummate artist and used her photo as the basis for an encaustic wax portrait.

▲ The beginning stages of this encaustic work of art by JuliAnne Jonker is a simplification of the original image.

◄ The finished image was created by applying layers of wax to the image.

⊘ DON'T DO IT!

Overlooking the Details

Great expressions are critical—but don't stop there. Pay attention to all the other details, too. Prior to releasing the shutter, carefully study the model and each element in the frame to make certain everything is in order. Attention to detail is important in all sessions. Issues like a crooked necklace will become all-too obvious in postproduction—but they are much easier to correct *before* you capture the image!

⊘ DON'T DO IT!

Keeping the Group Too Close

Closeness can help show unity, but "mob photos" do not make pretty pictures. Using some negative space in groups (and also with individuals) will improve the composition of the portrait. Practice inserting a pleasing variety of negative space between the arms, legs, and bodies when arranging families or other groups. Squint your eyes to determine how the outline looks in silhouette.

MISTAKES 55 AND 56

Common Issues with Details and Groupings

▲ It is easy to get wrapped up in looking for a great expression and forget small details that become obvious during post-processing – like a crooked necklace (left) or a big, black modern watch (and hair band) on the wrist in a 1940s-inspired glamour portrait (right).

▼ Ted York arranged some members of this family behind the fence, some in front – all nicely placed with good negative space and without being smashed together.

MISTAKE 57

Having Everyone Look at the Camera

🚫 DON'T DO IT!

▲ Taylor Lewis, a film student at Brigham Young University, created this enchanting engagement-portrait setup on a rainy day in the forest. Neither subject is looking at the camera, so the images have a "candid" feel that contrasts perfectly with the clearly out-of-place props.

A re you kidding? How boring. Having the bridal party springing into the air may be passé, but someone in the group usually requests it. Even so, try to think of something more original to say other than, "One, two, three—jump." How about exclaiming, "Who's happy this guy is out of circulation?"

Tips to Get Them Excited

Use motivating methods to set fire under a group and get them interacting—instead of just staring at the camera.

- Set a target area for the group to "land," then get them to run there from a starting point near your camera.
- Arrange a group on steps, a large rock, or a sofa—then tell them to switch places at the

count of three. Repeat, "Three!" Repeat, "Three!" Continue shooting and counting while the turmoil unfolds.
- Hum a tune and have them break out in dance, then form a group again where they stand.

▼ Motivate a group by saying something that lights their fire.

Having group members put their arms around each other may create more than a sense of unity—it can also produce unflattering pulled jackets and crooked ties. The fatigue and hustle-bustle of weddings can cause details like these to get overlooked. The "group clutch" look may be a crowd-pleaser, but you shouldn't allow mob rule to dictate the pose! Step in to arrange the group members with imagination. Liberate them from the cluster—and use other ideas to show unity (see Ted York's photo below).

And don't forget: when photographing groups, you should always take enough frames to give you plenty of fodder in case a head swap or other replacement is needed.

MISTAKE 58

Using the "Group Clutch" Pose to Show Unity

⊘ DON'T DO IT!

► After a long day of shooting a wedding, it's easy to overlook problematic details like a gaping jacket.

▼ Ted York likes to ask his clients if they have any particular interests that define them. "This family immediately responded by voicing their interest in reading. The morning of the shoot they showed up with two boxes loaded with books. The resulting image is one that speaks of them and who they are."

MISTAKES 59, 60, AND 61

Issues with Timing, Posing, and Cropping

🚫 **DON'T DO IT!**

Shooting the Smooshy Part of the Kiss

Encourage a passionate kiss in an engagement session—but shoot it *before* the smack. Set up the shot to capture the moment before the kiss by asking them to "warm up" for it.

Why? Well, a smushed-up, sucky face doesn't actually look very romantic in print. The pre-kiss, whether formal or informal, tends to look more romantic and adds a sense of tension that invites the viewer to linger on the image.

🚫 **DON'T DO IT!**

Pressing the Flesh Too Tightly

Skin-to-skin contact can show love and closeness—but easy does it! Be careful not to squish or distort skin by allowing the subject to press too hard. When you want to portray the closeness between subjects, ask your models to "barely touch" (demonstrate it, if need be). This is especially important for the faces. Facial distortion is not pretty—and that type of reconstructive surgery is difficult to perform in Photoshop.

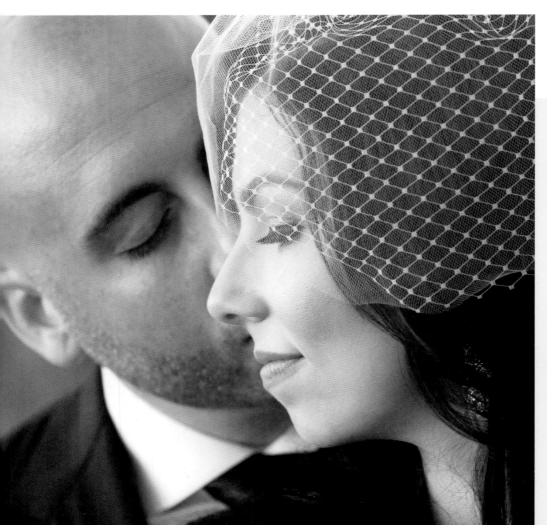

◄ The moments leading up to a kiss can be more pleasant and inviting to the viewer. Photo by Scott Nelson.

▲ Cynthia Pace created a tender image by suggesting the girl barely touch her mom's tummy.

▲ The "light touch" concept also applies to single subjects interacting with their own skin—as illustrated in this dramatic image by Joel Grimes.

⊘ **DON'T DO IT!**

Cropping at the Joint

It's not a bad idea to use the arms or legs to help frame a shot. When including appendages, however, make certain the fingers or toes don't appear amputated. The rule is to not crop the image at a joint. When showing a fraction of the arm (as pictured below, left), it's not good to have the girl's fingers disappear behind the flower in her hair.

▲ In this image, the fingers are missing and the eye is covered. When I noticed this error, I gave the model a few minor instructions to recover the fingers and part of her covered eye.

▲ Although the problems were corrected in this image, the first shot still remained the favorite for both the photographer and client.

MISTAKE 62

Insisting That *Everyone* Smiles

⊘ SOMETIMES OKAY

Not always. People naturally associate "camera" with "smile"—and subjects in groups are expected to smile even more than a single individual. But think about it. How many images in *Vogue* depict a gorgeous model with a big, cheesy grin on her face?

The feeling portrayed in your photograph should be captured with your client's personality in mind. To get an authentic expression, plant some sort of emotional vision in your subject's mind. Thoughts and feelings will naturally play out on the face. Collect prompts that work for you to get the look you want. "Smile with your eyes" and "relax your lips" are both good phrases to prompt a pleasant look without a full smile.

❝ The feeling portrayed in your photograph should be captured with your client's personality in mind. ❞

◄ Ted York's *Little Sophisticate* depicts a young man looking very serious in his suit and tie. A smile and neat tie would have destroyed the unique mood of this portrait. York recalls, "This young man was the best. He was very casual and cooperative, so I was able to capture him in an intriguing way. The beauty of this image is his expression. He is not frowning, but he is not smiling either. Viewers are immediately captivated by the boy's eyes, and the portrait draws you in."

ere's a common idea: It doesn't matter which direction a subject is running, the subject will be blurry if the camera's speed is set too slow. Gotcha! Couldn't resist. Just had to include this myth that my mother taught me decades ago. When I give a photography test, 95 percent of my students get this question wrong. The truth is, you will have a better chance of avoiding blur if the moving object is coming toward you rather than running laterally across your line of sight. (Obviously, common sense would dictate that you *avoid* this technique with trains or any other potentially dangerous objects coming toward you at a high speed!)

Not Accounting for the Moving Subject's Direction

🚫 **DON'T DO IT!**

❝ When I give a photography test, 95 percent of my students get this question wrong. **❞**

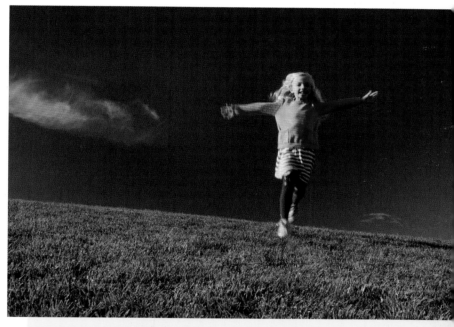

▶ **TOP**–When the girl is running toward the camera and photographed at a shutter speed of 1/40 second, the areas of extreme blur are limited to her hands and feet.

▶ **BOTTOM**–However, when she is running laterally across the frame (and photographed at the same shutter speed of 1/40 second), the blur is really accentuated.

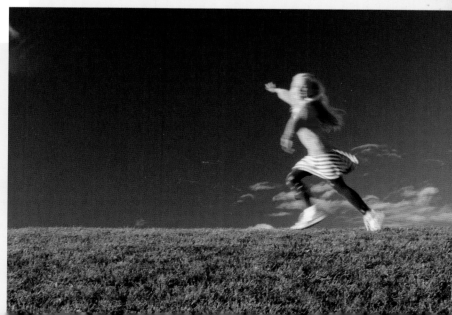

MISTAKE 64

Shooting Only What the Client Requests

🚫 **DON'T DO IT!**

D on't stop with what the client asks for! Capture what the client wants, then (with your client's permission) create what you have in mind. Don't miss the chance to exercise your creative energy and go beyond the expected shot!

Make certain you have given creative thought to the photo concept long before assembling your gear for the session. Creativity and innovation is what introduces art into a photo session and invites "oohs" and "ahhs" from the client when they view the resulting images.

Practical Example

JuliAnne Jonker remembers the words of one of her early mentors, "One for thee and one for me." Essentially, this means capturing what your client wants first (be sure you get it)—but then, if they are open to it, doing another image that reflects *your* vision.

For this session, the color headshot was what Jonker's client wanted for her senior portrait. But they also wanted her to do something more unique and gave her creative license. "When I add my own artistic vision to the session—of course collaborating with the client as we go—the images we create usually end up as the large portraits on the client's wall," says Jonker.

The original concept presented by the client may not result in anything larger than an 11x14-inch print, but the results of the more creative "extra" sessions cry out to be wall art. In this case, her artwork ended up not only on the client's wall but also in magazine articles and in the Professional Photographers of America National Loan Collection.

◄ ▼ ► **THIS PAGE AND FACING PAGE** – Here is a series of images that JuliAnne created out of just one senior photo session. Photos by JuliAnne Jonker.

MISTAKE 65

Wrapping Up the Session Too Soon

🚫 DON'T DO IT!

Are you worried you might wear out the client by shooting too many frames? Not so fast! Sometimes, what the photographer has in mind just doesn't work out. When that happens, don't be in a hurry to get the client out the door. Keep trying new things and progressing toward an image that really works.

Practical Example

A woman approached me about capturing an image of her mother. I pictured a stately matriarch in a stately chair. During the session, I clicked through several poses. While I wasn't extremely pleased with any of them, I thought I could make something out of what I got. I shut down the lights and we joined the rest of the family in a room outside the shooting area.

As we chatted for a few minutes with other family members, I noticed how my diminutive model was sitting with her hand placed pensively under her chin. There it was! That was the needed pose. I invited her back into the studio where I reset the lights and captured something that I had not originally envisioned. Of course, that was the one the family ordered.

> ❝ I noticed how my diminutive model was sitting with her hand under her chin. ❞

▲ This was the best I got out of the session before exiting the shooting room.

◄ This "after the session" redo was the one that showed more of the woman's true essence.

D o the arms and legs always have to be accurately in proportion with the body? Not always.

Body parts that are closer to the camera will look bigger, which can be a blessing or a curse. As shown in the example below (left), you wouldn't normally want to put the feet in front of the subject's head and shoulders. Doing so will make those feet look pretty large.

However, you can also make this rule work for you. For example, you will often find that your subject has one eye that is slightly larger than the other. In this case, positioning the smaller eye closer to the camera will make the eyes appear the same size.

Renaissance painting masters made it a point to make their subjects look good. They carved off pounds and removed blemishes. Today, shedding a few "pounds" here and there is fairly easy to do using Photoshop's

MISTAKE 66
Not Controlling the Proportions

⊘ DON'T DO IT!

Liquify tool. However, you should make it a point to "size up" your subject before shooting. If there's a larger person in the group, try placing them farther back for a better visual balance with the other subjects. If your female subject has larger hips, shooting down from a higher angle (putting the hips farther from the camera than her face and shoulders) will minimize their appearance. Turning a curvy woman sideways will also help.

▼ This may have been a cute idea for a pose but the "featured" feet just didn't work for the client.

▼ Consider playing this optical tactic to your advantage. The girl's outreached hand creates drama for this Halloween cookie-frosting fiasco.

MISTAKES 67 AND 68

Common Composition Issues

🚫 DON'T DO IT!

Dismissing the Old-Fashioned Rule of Thirds

Don't dis all photographic "standards." Why ignore a powerful rule of composition that makes photographs more interesting and dynamic? This rule should always be in your mind while blocking or cropping a photo—even if you decide to break it. The Rule of Thirds may be as old as the hills, but it's still extremely viable and in no danger of going out of vogue.

▲ The young man remains the center of interest in this composition, which incorporates a strong interpretation of the Rule of Thirds.

🚫 DON'T DO IT!

Centering Your Subject

This is so ho-hum. Consider your end product. Does the customer only want an 8x10-inch print for their desk? If that's the case, you are pretty much stuck with creating a middle-of-the-frame subject without much room for creativity. Want to seller bigger prints? When you capture a lot of real estate in the frame, the images practically cry out, "Print me large!"

◄ Off-center subjects in a grand scene are extremely interesting – and also the current hot item in creative photographic design. This beautiful wedding image is by Scott Nelson.

Should you crop in-camera to preserve as much detail as possible? No. This was a valid concern in the early days of digital capture, but now we can step back and still have plenty of pixels to crop significantly in postproduction without overly compromising the image quality. So don't cut yourself short by cutting off acreage that you might want to use later. Instead of zeroing in on your subject, if more landscape is available, take it in. It's better than being sorry later.

Practical Example

A tightly framed dog portrait might work well on a wall or desk, but including more space around the dog will add to the usefulness of the image. Step back enough to allow for both vertical and horizontal crops in post-processing. If shooting for stock sales, consider that a buyer might use it for a calendar (usually horizontal) or a magazine cover (almost always vertical).

Clients, too, sometimes decide they want a different ratio of the image for over their fireplace mantel. I once had to create a 24x30-inch print from an image that was tightly shot at a 20x30-inch ratio. Fortunately, all I had to do was add a little sky and matching dirt at the top and bottom.

CATEGORY: POST-PROCESSING

Digital photography does not end when the card leaves the camera. Much of the "art" comes in post-processing. Images of people, places, and products all benefit from retouching. First, make the initial changes (exposure, color balance, sharpening, lens correction, etc.) in a RAW editor. Then, move on to Photoshop—or Lightroom's Develop Module—to make additional modifications, if necessary. Further retouching in Photoshop may deal with smaller details such as perfecting the skin, filling in the hair, and getting rid of distractions like wires and poles in a landscape.

MISTAKE 69

Cropping Tightly in the Camera

🚫 DON'T DO IT!

Pooch *on the Go*

Kayaking off Washington's Samish Island

November

▶ A tight shot is nice (top left), but capturing more real estate around the dog (top right) gave the image greater flexibility for later use – potentially as a magazine cover (bottom left) or calendar page (bottom right). Here, the light was from the early morning sun, not flash.

MISTAKE 70

Thinking That Lightroom Is More "Professional" Than Photoshop

⊘ DON'T DO IT!

I t's not about which software is more "professional," it's about choosing the right tool for the job. If you think about it, both Lightroom and Photoshop are Adobe products. Why would they create *two* software programs that do the same thing? Instead of choosing one or the other, it makes sense to become proficient in both programs in order to make better decisions about which one to use to accomplish a desired goal. The following are just a few brief points in ways that Lightroom and Photoshop differ from each other. (*Note:* Want to see the screen shots larger? Refer to the instructions that appear on page 2 of this book.)

Lightroom

Lightroom has the same RAW editor as Photoshop, as well as a Catalog (Library) for naming, selecting, storing, and keywording images. The process of working on virtual images in Lightroom is nondestructive, plus batch corrections of exposure and other tweaks are easy. The selection of image modification tools is not as extensive as in Photoshop, but it is adequate for performing general enhancements. Some photographers do what they can in Lightroom and then move on to open the image in Photoshop if necessary.

Photoshop

Photoshop is used to make more extensive manipulations to an image. Layers and Layer

◄ The sky in this image is dramatic. (Shoot RAW to have more data available.) If the entire image is lightened, however, the sky becomes washed out. This is where Photoshop's Layers come to the rescue.

▲ I duplicated the layer of the background image (Cmd/Cntrl + J), then went to Filter > Camera Raw Filter to lighten the image in the top layer. As I did, red blotches in the sky became visible because the Clipping Mask (right-hand corner of the histogram) shows overexposed areas.

▲ I added a Layer Mask by clicking the triangle with a circle in it (located at the bottom of the Layers panel). After making certain that the color swatches were set to black and white (press the D key) with the black on top, I used the Brush tool to color the original sky back into the top image.

▲ My corrections spilled over onto the roof and statue, so I used the X key to reverse the color swatches (putting white on the top). Then I used a small brush to paint away the accidentally darkened areas. (At this point, you can preserve your work in layers by saving as a PSD file – or go to File > Save As to create a JPEG.)

▶ It took under three minutes to apply the Layer Mask and combine the dark sky with a lightened version of the foreground. On second thought, though . . . after all that manipulation, this "morning after" image of a square in Lisbon might have been better left dark. In the lightened version, we can see all the unsightly litter left after nightly drinking in the square!

Masks are what make Photoshop a powerful tool for background swaps, composites, etc. With Content Aware fill, you can easily move an object to another part of the image, leaving little trace of where it once stood. The Healing Brush and Clone Stamp tools are essential for retouching.

Photoshop also comes with Bridge, which some photographers use for sorting images. Other photographers prefer newer programs for selecting and filing images. More on this in section 72.

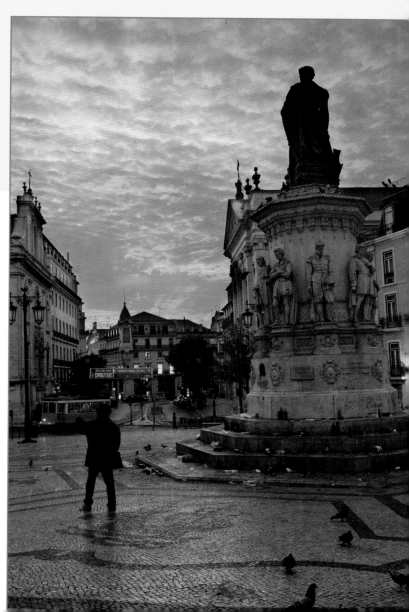

MISTAKE 71

Using Inefficient Image Selection

🚫 **DON'T DO IT!**

t's easy to waste a lot of time on poor workflow habits. A huge culprit is the task of sorting images.

Select *In*, Not *Out*

When rating photos after a session, it's common for photographers to weed out the bad ones as they go. As it turns out, the opposite approach is actually more efficient. It might seem intuitive to move through the captures and sort out those of lesser quality, but it turns out that cherry-picking only the best images actually saves a great deal of time.

Jared Platt's Advice for Streamlined Photo Selection

- **Positive Select**—Identify the best images. Never use the reject key and don't bother with rating.
- **Compare Groups of Images**—Always select photos in comparison to each other, looking at four to six at a time.
- **Focus on the Task**—Make better choices by eliminating other distractions (such as a movie on another monitor).
- **Don't Second-Guess Yourself**—Trust your gut instinct; your trained eye will tell you what is right.
- **Consider Hardware Aids**—Try using the ShuttlePRO v2 editing controller, a hand-held device that is more affordable than one would expect.

More Pro Tips

Photographic artist and convention presenter Jared Platt processes hundreds—sometimes thousands—of images after a session and stresses that the first rule of selection is to look at the images in comparison, not individually. He also advises against becoming a "photo hoarder." Most professionals agree that 90 percent of all shot images need to be tossed. "Don't get hung up on small details that don't matter," advises Jared. "Minute differences that might matter to you will not make the least bit of difference to the client."

◄ Jared Platt prefers to sort photos with the hand-held ShuttlePRO v2SB controller.

Adobe Bridge was once the best way to sort and rate photos. Although Bridge is still used by many professionals, there are many other software options now available to compare photos. It's hard to retire old methods, but newer ways to process photos are fast and reliable. Lightroom is not the only new kid on the block. (I know—it's shocking!)

My sorting method of choice is Photo Mechanic by Camera Bits (camerabits.com). When I put a card in my uploader, the images open directly into Photo Mechanic. From there, they can be quickly loaded into permanent or temporary folders on my hard drive.

This software is popular among discriminating photographers, and I once heard a well-known landscape photographer describe it as "sorting on steroids."

Overlooking New Software Options

⊘ DON'T DO IT!

▲ Photo Mechanic is fast and agile but not hugely complicated with a lot of frills. It will recognize most all file formats for RAW imaging.

▶ **TOP RIGHT** – Photo Mechanic's thumbnail slider (top left) controls the number of photos shown on the screen. You can drag and drop to switch file locations using the column on the left.

▶ **CENTER RIGHT** – Photo Mechanic is a powerhouse for photographers who need to plow through images, inspect closely (is 800% magnification large enough?) and quickly move and sort to different folders.

▶ **BOTTOM RIGHT** – Switch to Photo Mechanic's Preview screen to check the metadata, histogram, and rows of nearby images (bottom).

MISTAKE 73

Not Standardizing Your Workflow

🚫 **DON'T DO IT!**

When post-processing, it's easy to want to start by correcting whatever problem stands out most in an image. That's a mistake. Don't jump around in your work habits. It's more efficient to establish a consistent workflow and get into the habit of using the same sequence to process each image.

Suggested RAW Workflow

1. White Balance. One of the easiest ways to achieve true color in Adobe Camera Raw (ACR) or the Develop Module of Lightroom is to access the Eyedropper Tool and click it on a white area (not a bright spot coming from light, but from actual color in paint or clothing, etc.).

2. Auto Selection. Both ACR and the Develop module in Lightroom have an "Auto" button in the Basic>Color section. Try clicking that first. It can be undone if you don't like it and want something more customized. If it's a good start, keep it and then go on to make additional tweaks.

3. Exposure, Clarity, Shadow, Highlight. All four of these functions provide the potential for major improvements. Clarity is a more "delicate" way of handling contrast. Try this before adjusting the shadows and highlights. (*Note:* Take care adjusting the Clarity slider in portraits because it accentuates lines in the skin; more on this in section 77.)

Then, go to the Shadow and Highlight sliders to see how they affect the image. Continue to check the histogram as you go. Click the upper right or left arrows in the histogram box to check for "clipping" (the absence of pixels in very dark or light areas). Another way to check for clipped pixels is to hold down the Opt/Alt key while moving the sliders.

4. Whites/Blacks. Adjust the Whites and Blacks according to your vision for the final image. Enhancing the Blacks works well for landscape photos.

5. Vibrance. Vibrance is to Saturation as Clarity is to Contrast. It is light-handed and intelligent. Saturation brings up all the colors linearly, while Vibrance works more with the skin tones. Because it softens oranges, this tool is especially useful when retouching portraits that show a lot of skin. The same feature, conversely, makes it a poor adjustment to use with sunsets.

6. Vignetting. Vignetting helps the subject stand out from the background. This tool has a tendency to be overused in retouching. (In Lightroom, you'll find this tool in the Effects panel.) Become familiar with the way the Amount, Midpoint, Roundness, Feather, and Highlights settings affect an image and use them to suit your specific vision. In Lightroom 5 and later, you can also enjoy using the many options of the Radial filter.

What About Cropping?
Some people include cropping as an initial step. However, cropping is not advised for stock images because an art director might have a need for a different crop. Why do all that retouching work on a cropped photo only to find out you need a different aspect ratio? (More on this concept in section 69.)

I f an image is out of focus, you can just sharpen it in post-processing, right? Hogwash. Sharpening in Photoshop will not elevate a blurry image to an acceptable level for a professional image.

▲ This image is in focus. Primary focus in a portrait is normally on the eyes (at least one of them).

◄ Enlarging the view to see the detail shows the sharpness of focus.

▲ As shown on the left, the most critical area – the eyes – is out of focus, probably from camera shake. Applying sharpening in post-processing (right) really doesn't help it.

MISTAKE 74

Trying to Sharpen Blurry Images

⊘ DON'T DO IT!

When reviewing your photos, inspect them at a sufficient magnification to spot those that are out of focus. Your editor should allow you to enlarge sections to 100 percent or more. While blur is acceptable in some areas of a photo (see section 14), at least one part of it should be in focus (*e.g.*, the eyes in a portrait). It is possible to soften an image to decrease wrinkles, etc.—but there is a big difference between an out-of-focus image and one with selective softening carefully applied with software like the Gaussian Blur filter. Don't try to soften an image by shooting it out of focus.

Shoot Multiple Frames

Beginning photographers usually struggle with incorrectly focused images. Even those who are more advanced don't get it right all the time. That's why multiple images are required to make certain you have the focus in just the right place. Overall, autofocus helps keep an image sharp—but it's best to tell the camera exactly where you want the focus to be (see section 50).

Eliminate Camera Shake

The other cause for blurry images is camera shake. Know the lowest possible speed that is safe for you to hand-hold your camera without causing blur. If you are getting too many "soft" images, use a tripod (see section 5).

MISTAKES 75 AND 76

Issues with Skin and Weight

▲ Access the Spot Healing Brush from the Photoshop Tools menu. Make the circle just a bit larger than the spot you want removed. Click. A black dot will appear, then disappear – and take the spot with it.

 DON'T DO IT!

Removing All Blemishes

The key word here is "all." What teenager is not self-conscious about his or her complexion? While acne is not cherished, a mole or a birthmark is generally left in place when retouching. Consult with the client if in doubt about something that might be considered sacred by its owner.

If you feel extensive retouching is not something you want to do, there are several programs (listed below) that might be a good fit for your style—if they're not overdone. Go easy on the skin softening in your portraits; leave some evidence that you have photographed a human and not a mannequin.

- portraitprofessional.com
- imagenomic.com
- on1.com/products/portrait9
- arcsoft.com/portraitplus

▲ In Lightroom, access the Spot Removal tool (next to the Crop tool) and work in the options box that opens. It's easy, once you understand the process.

DON'T DO IT!

Offering Digital Weight-Loss Miracles

Assuring clients you can retouch out all their unwanted pounds is not a good idea. ("Oh, so you noticed?" they might think.) It's not cool to bring up the subject of a subject's "rounded" form. If you are skilled at retouching, you should discretely make your clients look their best. You simply want them to exclaim, "You made me look so good!" They should not suspect that Photoshop's Liquify filter ever even entered into the process. If the subject of weight enters your discussion with a client, consider using flattering terms such as "curvy" and "curvaceous" in your dialogue.

▼ The removal of small blemishes is a snap with Photoshop's Spot Healing Brush, Patch tool, or the Spot Removal tool in Lightroom. In regards to strongly pigmented areas, consider the option to simply lighten them rather than completely obliterating them.

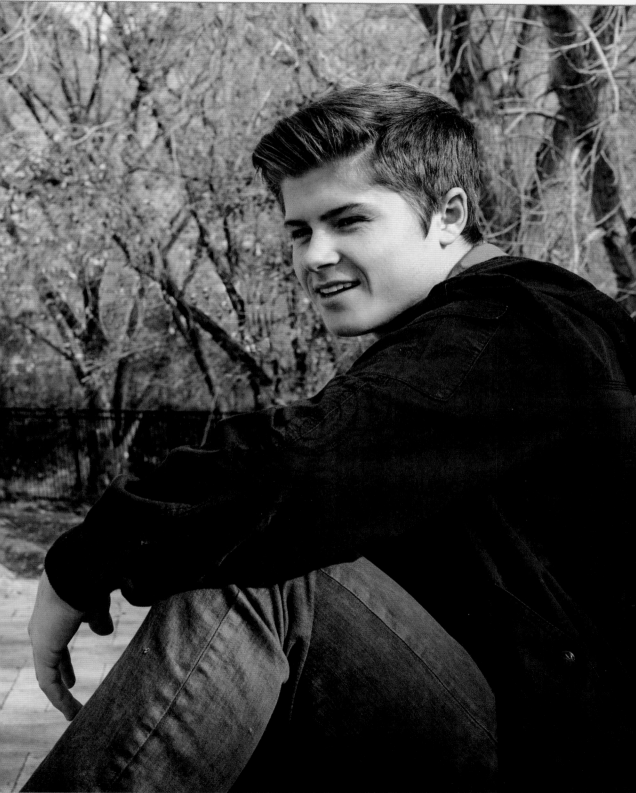

MISTAKE 77

Cranking Up the Clarity Setting

🚫 DON'T DO IT!

Do you just bump up Photoshop's Clarity setting to sharpen the eyelashes in a woman's portrait? Not so fast. Think about it. If the eyelashes become more defined, so will lines and creases. Women don't appreciate that type of enhancement.

There are various ways to add softness to a woman's face while keeping sharpness on the eyes and eyelashes. The good thing about Photoshop's Layers is that they make it easy to soften some parts and sharpen other parts by creating a different layer for each task.

For example, to soften lines in a portrait, you can simply apply the Gaussian Blur filter (Filter>Blur>Gaussian Blur) at the desired level, then bring back the sharpness in the eyes and mouth using the Brush tool on a Layer Mask.

That's only one way to get the job done—you should use whatever method looks and feels best to you.

▲ Boosting the Clarity or Contrast setting will increase the lines.

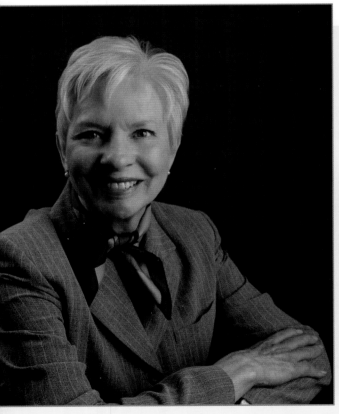

▲ It doesn't look quite right to make a woman's skin devoid of all lines.

▲ Smooth lines in the skin by applying an all-over Gaussian Blur, then bring back the sharpness in the eyes and mouth using a Layer Mask.

MISTAKE 78

Adding Texture to a Portrait

🚫 SOMETIMES OKAY

▲ Behind the stark white of the girl's dress, the background texture is captivating enough to become an integral part of the creative vision. Photo by Ted York.

▼ An even bolder approach is to apply multiple textures in Photoshop and experiment with layer Blending Modes. Most of the skin was cleared, but hints of texture were left around the edges of the model.

Easy there, pard'ner. Photographic texture is a pattern (usually one that is subtle, without bold lines) that is superimposed over the main photograph. Textures are often created by photographing marble, crackled paint, stucco, etc.

If the layered texture is too heavy, the results can be hideous. If it's applied thoughtfully, however, adding texture can definitely enhance a portrait. One of the keys is to use a Layer Mask in Photoshop to remove unwanted texture from the subject's face and other areas where it is not wanted.

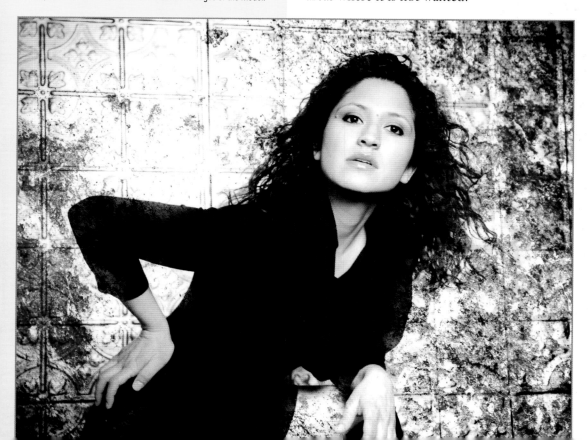

MISTAKE 79

Always Doing Your Own Retouching

⊘ SOMETIMES OKAY

Do true professionals always do their own retouching to maintain control? For the most part, no. Retouching is a giant time eater and it can be tricky to get it right. While some professionals enjoy doing their own retouching, most commercial photographers don't hesitate to call on a high-end professional to ensure the best-possible results.

Advice From a Pro

Pratik Naik (solsticeretouch.com) takes pride in his work as a high-end retouching artist. That's why his talent is so much in demand. "When a client or a photographer comes to me in regards to a job, it's always a unique experience," he says. "We, as retouchers, typically review the images and the needs of the client before working on the images. As each person is different, so is their request. We usually have our own ideas on how to improve on the portrait. Typically, the goal is to keep the person looking like themselves on their best day. We try not to make them look a lot different than they really are.

"Once we obtain the directions, we give a quote on the job itself and how much it usually costs. For myself, I base it on the time the requests will take and rate it at $60 per hour for anything that is non-commercial in nature. Usually, this amounts to $60–120 per image. It varies for different uses, of course. After the retouched image is delivered, we wait until we receive word on any revisions that may be needed. If not, the job is finished."

When to Outsource

As a professional photographer, you should still learn basic retouching skills—and especially what *not* to do. You must know at least enough to advise a retoucher as to what you would like done to your photographs. Don't have a big budget for retouching? Try using retouchup.com. They have three levels of retouching services to select from. If you don't like the results, they will re-do the work.

On-Line Resources for Affordable Retouching
- colorati.com
- fotofix.com
- retouchup.com
- toucia.com

▲ Original image prior to retouching.

▲ Professional retouching by Pratik Naik.

MISTAKE 80

Using Plugins, Actions, and Filters

⊘ SOMETIMES OKAY

Plugins, actions, and filters (three names for essentially the same kind of software) are designed to apply special effects or enhancements to your photographs—often with one click. Some plugins require Photoshop as a host software; others operate on their own.

▼ This image was submitted as a competition print when actions first became available. Judges commented that the "treatment" was overdone; therefore, it did not get enough points to receive a merit for PPA print competition.

For instance, OnOne (on1.com) is a stand-alone program that performs a wide variety of tasks, such as background replacement, retouching, black & white conversion, and noise reduction.

Potential Problems

That all sounds good, right? It can be, but too often photographers overdo it with plugins and end up with disastrous consequences. Some plugins can degrade the quality of an image. Often, plugins will add a lot of noise or just produce "special effects" that look unnatural.

When Plugins Work Well

When used correctly plugins can save time and improve your photographs. If a photograph needs to be upsized for a large wall print, don't think that resampling in Photoshop will be adequate. Maintaining quality while upsizing images requires the "refined touch" of a program like OnOne's Resize. Resize does an absolutely amazing job of depixelating images while upscaling.

Likewise, you should not convert a color photograph to black & white simply by desaturating the color. There are several better and more nuanced approaches, depending on the results you want and how much time you want to spend. An easy route is to use Nik Silver Efex (google.com) to make fabulous black & white conversions—but be sure to watch for added noise.

Popular glamour photographer Sue Bryce raves about applying Alien Skin (alienskin.com) to her images. On the facing page (top photo) is an example from Alien Skin's Exposure 7 collection, where I applied textured scratches to make the frame of the mirror look old.

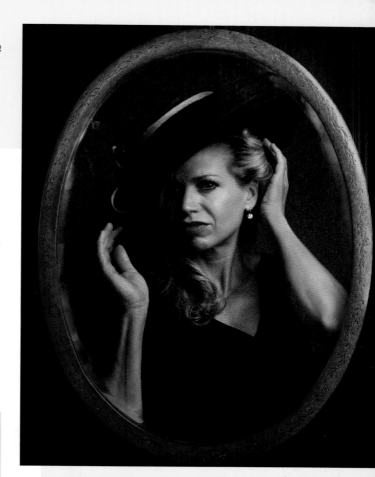

▶ **TOP RIGHT**—Not all plugin filters are destructive (but they can be if used with a heavy hand). Here, Alien Skin was used to apply a distressed texture to the frame of the mirror.

▶ **BOTTOM RIGHT**—Alien Skin uses a very light touch to apply enhancements to an image.

Finding and Using Plugins

The Internet offers abundant plugins for photographic enhancement and alteration. Some are more well-known than others. As you experiment with plugins, keep in mind that many software companies offer free trials. When you find something you like, create a recipe for using that plugin—or write your own action and save it for quick application on future images.

Resources for Actions and Plugins

- **Alien Skin**—Assorted image enhancements (alienskin.com)
- **Jbiz**—Assorted image enhancements (actions4photographers.com)
- **Kubota**—Assorted image enhancements (kubotaimagetools.com)
- **Nicole Van Flourish Actions**—Contemporary color pop (nicholev.com)
- **Nik Efex**—Color, black & white conversion, HDR, sharpening (google.com/nikcollection/)
- **OnOne**—Enhance, resize, mask; plus free Lightroom presets (on1.com)
- **Tiffen Dfx**—Enhancements, textures, deNoise, and much more (tiffensoftware.com)
- **Topaz**—Adjust, black & white conversion, clarity, noise reduction (topazlabs.com)
- **Wanderlust Artistic Actions**—Trendy hues (ohsoposhphotography.com/artstore/product)

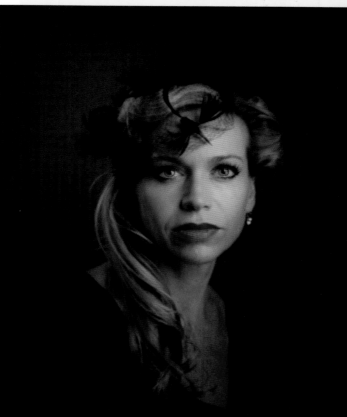

MISTAKE 81

Making Poor Cropping Choices

🚫 DON'T DO IT!

I s it *never* okay to crop off body parts? Of course not. As the images in this section show, it can be done effectively. So go ahead—chop away.

However, keep in mind that effectively implementing your artistic license in this respect requires lots of experience. While Jason Voorhees might have easily hacked off limbs in the *Friday the 13th* movies, photographers should approach the amputation of body parts in their images with a lot more finesse. In particular, arms or legs that are chopped at the joint may be unsettling to the viewer.

To maximize your options, keep all those body parts in the frame while shooting and crop later.

▶ **TOP RIGHT** – JuliAnne Jonker orchestrated a unique composition for this senior portrait. Seniors appreciate this look, which is borrowed from the influential fashion industry. The absence of a head creates intrigue, while the pleasant S-curve and movement in the hair allows us to pause and enjoy the pleasantries in the arrangement of the shapes. Pore over fashion magazines to get ideas. Rip out the images that catch your imagination and keep them in an "inspiration" folder.

▶ **BOTTOM RIGHT** – Infrared imaging, as shown in this photograph, can make the skin look like alabaster. The scarf used here was actually black, but the infrared light picked it up as a lighter tone – while, at the same time, making the sky and water go quite dark. Unusual cropping was used to enhance the impact of the image.

► Jen Hillenga was the inspiration for this photo. She says that when a client questions her about cropped hands or top of a head, she quips, "I chopped off the feet, too. Did you notice that?" Normally, a hand would not be chopped in the middle of the fingers, but it's all about the artist's vision. In this close view, the partial hands work to frame the model's face. In a full body shot, cropping hands like this might not work as well.

▼ Dramatic cropping helps a photographer tell a story. In this image, you don't need to see any more of the scene to understand the story – and including more might even have spoiled the impact of the photo. Photo by Jennifer Bacher.

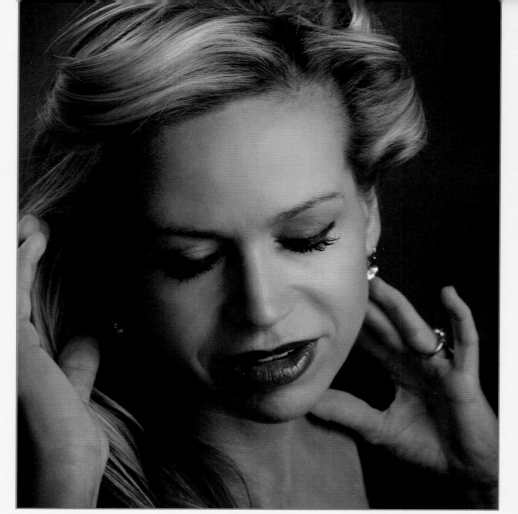

The business side of photography usually gets put on the back burner because photographers tend to feel more like artists than business owners.

MISTAKES 82 AND 83

Not Drawing on the Experience of Seasoned Pros

▲▶ **ABOVE AND FACING PAGE** – My image of a girl bending forward (facing page) was composed and shot after I was inspired by a painting in a Minneapolis art museum (above). The red sketch shows the "inspiration" piece – and you can see how it directly inspired my own work.

⊘ DON'T DO IT!

Being Afraid to "Bother" Other Pros

Think other photographers won't want to help you? Don't believe it! Find a mentor. Most leading photographers in the business started out with a mentor. If the mentor wasn't a friend or family member, it was a person who took them on as an unpaid assistant or provided another means of instruction and support.

⊘ DON'T DO IT!

Being Afraid to "Copy" Inspirational Images

Don't feel guilty about getting inspiration from others. Steve Jobs made no excuses about his penchant for copying. Early oil-painting masters blatantly copied each other, too.

Even if making a direct copy was the goal (and I don't suggest you make that a habit), the use of different lighting and other personal and situational influences makes it almost impossible to come up with an exact duplication of someone else's creation. I feel there is a "spirit" connected to the creation of each work of art. If someone tries to copy work almost pixel for pixel, it doesn't carry the same

spirit with it and falls flat. There is something magical that happens when you make art your own.

Don't be shy about seeking inspiration from others—especially when you're starting out. Visit art museums to marvel in person at how the masters of oil applied light in their images and how they posed the body (especially hands, legs, and feet). Allow the spirit of masters in all creative media to rub off on you and elevate your personal creativity and artistic expression.

Topaz "Impressions" software was used here to add a painterly effect. This intuitive software varies strokes according to the lines in the image it is interpreting.

MISTAKES 84, 85, AND 86
Style & Service

🚫 DON'T DO IT!
Failing to Offer Videography Services

Get on board. Why not add video to your photographic repertoire? Current digital cameras are capable of excellent video. They are compact and easy to use as well as process. More and more professionals are providing videos as well as stills.

🚫 DON'T DO IT!
Going Overboard with One Technique

Planning to shoot an entire wedding in infrared? Don't go overboard! Obviously, you haven't had much experience with infrared

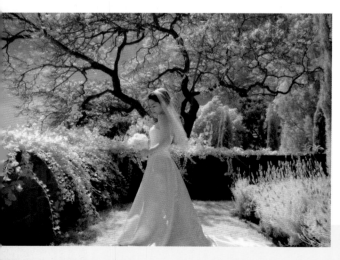

photography if you envision shooting an entire wedding with a digitally converted infrared camera. Infrared can be unpredictable, so it should be used like a delicious treat—not for an entire meal. For the latest and most complete information on digital infrared photography, I suggest my book *Mastering Infrared Photography* (Amherst Media). It provides a wealth of information on both color and black & white digital infrared techniques.

🚫 DON'T DO IT!
Not Taking Candid Images

First of all, don't confuse ordinary snapshots with candids. The word "candid" means forthright, truthful, and straightforward. Capturing images that embody those ideas requires considerable thought and experience. Accordingly, this style of work is often referred to professionally as photojournalism or lifestyle photography.

The candid photographer carefully (but quickly) needs to sum up light and composition while encouraging authentic moods and activities from subjects. Creative vision is also needed before the shoot to "stake out" the intended shooting location (whether a home, office, or park). Even so, the preplanning often goes "poof" and leaves the photographer to adjust his approach on the fly, while working with the moving targets in a family.

◄ **TOP LEFT**—Scott Nelson captured this beautiful bridal shot with a converted infrared digital camera.

◄ **BOTTOM LEFT**—Storey Wilkins has a photographic style that shouts "LIFE!" in big letters. During each family photo session Storey advises, "Aim for three different family poses in three different locations." Her images reflect the happiness families get from doing everyday things. "Life goes with light," she says. "Check out the images in *Vanity Fair*—the photos there are classic." Most of Storey's photographs do not show children grinning at the camera, but her heartwarming images garner oodles of smiles from people looking at them.

Think school and sports photographers are low on the photographic food chain? Nope. According to Professional Photographers of America (PPA), school photographers are some of the highest earners in the business.

Break In Early

It's not easy to break into this genre, but photographer Trish Logan found a way to get in at the preschool level—with images that outshine the green-screen or plain-background garden variety.

Logan says that preschools offer greater opportunities for capturing school business because they are usually more flexible with requirements and posing guidelines than are grades K–12 or higher. "When you can offer something more creative, parents seem to

Overlooking Opportunities in School and Sports Photography

⊘ DON'T DO IT!

take notice and respond with more enthusiasm. They often rehire you to photograph their entire family or older children alone."

So what works for Logan? Get the children outside in a natural setting where they are more comfortable and respond naturally. Encourage great expressions by allowing kids to be kids. Set them on posing rocks surrounded

▼ **LEFT AND RIGHT**—Trish Logan does the "little extra" by bringing leaves, a faux rock, and hats to the preschool photo shoot.

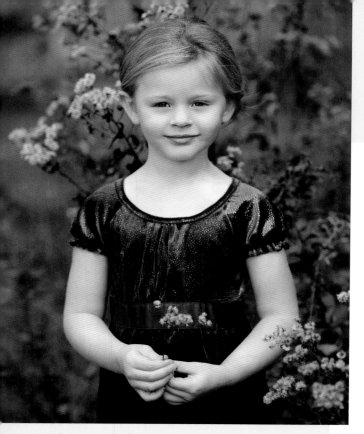

by artificial flowers or leaves (depending on the season) that can be incorporated with the natural landscaping to give a nicely finished portrait.

School photography can really work when you have the right subject, such as the girl in the purple dress (top left). "She appeared before the camera with a very classic look," says Logan. "Therefore, we ran with it by creating a timeless portrait that has high impact and looks nothing like a school photo."

Professional Support

The School and Sports Photographer's Association of California (spac-usa.org) specializes in providing support for school photographers. Join this group and attend their yearly convention to get ideas and inspiration.

Additional Income

Another source of income is through photography with Boy Scout troops—and a myriad of other organizations that have members who need to be photographed. William Hodge enhanced his ability to photograph young people in Boy Scout troops and schools by becoming accredited with Special Kids Photography of America (specialkidsphotography.com).

Many photographers think sessions with children who have special needs are difficult and not profitable. No so. "Most parents of children with disabilities don't want pity and special treatment," indicates Special Kids Photography of America, a nonprofit organization that provides training and accreditation for photographers who want to create beautiful images of children with special needs.

Parents, for the most part, yearn to have their special children mainstreamed into the school system as well as other parts of society—and that includes photographic services. They aren't looking for a handout; however, they *do* want to work with a qualified photographer who can create a wall-worthy portrait of their child. When that happens, parents quickly pass that photographer's contact information around. A photographer who recently achieved accreditation with Special Kids Photography of America (SKPA) shared this e-mail:

> "I just wanted to share some exciting news with SKPA. The day I got your e-mail saying I passed [accreditation], I posted it on Instagram [and] I was featured in the *Manteca Bulletin Newspaper*—and today I got an e-mail saying that *Good Day Sacramento* wanted to do a live feature of me. Accreditation [with SKPA] snow-balled into all this!"

As SKPA points out, because of medical and therapy bills, etc., some families cannot afford a photographer. They advise photographers to "provide services according to what the heart dictates—and have a big heart."

MISTAKE 88
Overlooking Kids with Special Needs

⊘ DON'T DO IT!

▶ Laura Popiel originally built her successful business in Houston, TX, by focusing on children with special needs.

MISTAKE 89

Being "Honest" by Entirely Skipping Postproduction

⊘ DON'T DO IT!

If you see a creative opportunity, take it. Even landscape photography benefits from enhancement—although it's best not to make it too obvious. Learn and practice what it takes to make an image look its best and even better than it was in reality, keeping in mind that no scene or subject benefits from looking overdone and overworked. That's not a pretty picture.

◄ **TOP LEFT** – A little work in a RAW editor made this photograph of Great Basin National Park ready for sending out to a stock photography company.

▼ **BOTTOM RIGHT** – While walking around after a WPPI convention in Las Vegas, I was attracted to the dramatic lines and colors surrounding an escalator. I asked a photographer buddy to lean on the middle stair rail between two escalators while I took a quick "snap." The shot was mainly intended for use on her Facebook page.

◄ **BOTTOM LEFT** – The image stuck in my head until one day when I needed some photographic R & R. A few swishes and swooshes here and there cut away my friend's coat, elongated her neck, and provided a new "do" for her hair. The rest didn't need much of anything.

S hould you stick to what you know you are good at doing? No. Take time to diversify and explore other genres.

Try Shooting Stock Photography

Stock photography is a world apart from a client-based business. If you don't like dealing with client relations and sales but love to put thought into creating solid, imaginative images, try doing stock. Qualification for acceptance by stock photography companies usually takes several go-arounds, so don't get discouraged by a few rejections. Keep trying. Follow the site's direction for success. Review the images on stock photography sites to get inspired.

Stock Photography Sites
- www.istockphoto.com
- www.bigstockphoto.com
- www.shutterstock.com
- www.gettyimages.com

" Qualification for acceptance by stock photography companies usually takes several go-arounds, so don't get discouraged by a few rejections. "

MISTAKE 90

Doing Only What You're Good at Doing

⊘ DON'T DO IT!

▶ **TOP RIGHT** – If you have a creative spirit, stock photography may give you a chance to soar.

▶ **BOTTOM RIGHT** – If you can't settle on a particular genre, stock photography can give you the opportunity to diversify and develop an outstanding portfolio.

MISTAKES 91 AND 92

Relying Too Much on Trust

🚫 **DON'T DO IT!**

Accepting Work Without a Signed Contract

Contracts are a must. In today's litigious climate, you should never take chances. Disclose all of your rules up front to every client—and do so in writing. Explain what you offer and what you expect. It is easy to forget important points when you are talking with clients about the details of the session, products, and sales procedures. A contract will make everything clear and help prevent unfortunate misunderstandings that not only cause hard feelings but can also be costly down the road if grievances occur. Sample contracts (including a photo release) are available at http://www.petapixel.com/2012/12/11/a-collection-of-free-sample-legal-forms-for-photographers/. It is especially important that you never photograph a wedding without a detailed contract.

🚫 **DON'T DO IT!**

Not Getting a Signed Release

"Trust your customers as you would have them trust you." That's a nice motto, but it doesn't work that way. Photographers may be timid about getting their clients to sign an official photo release that identifies who owns the photo (the photographer retains all rights) and for what purposes the images may be used. Trust is good, but when people don't understand your rules or change their minds, the release is there to provide security.

The language in a model release can seem strong at first read, but releases are a standard part of the business and grant permission for any future use a photographer may have for the pictures—including something as common as posting them on a web site.

Sample releases are available on the Internet. There is also a good app called Easy Release available for iPads. It is super-easy to use and also allows for an on-the-spot photo capture to accompany the release. Releases can then be sent directly to your computer for printing and storage.

> 66 A contract will make everything clear and help prevent unfortunate misunderstandings that can be costly down the road. 99

🚫 DON'T DO IT!

Posting Your Images on Free Sites

You might think you're saving money, but you get what you (don't) pay for. A web site is not the place to go "free" and still look professional. Two recommended photo web sites that professionals use for simple posting are Zenfolio (zenfolio.com) and SmugMug (smugmug.com). You can have your own domain name assigned to them. Zenfolio and SmugMug also offer cloud-based storage for images. Other affordable DIY web site builders are Squarespace, Wix, and Weebly. Take a test drive by means of a free trial. It doesn't matter how much you spend on a web site, just make certain it looks professional and features first-class images.

🚫 DON'T DO IT!

Posting Too Many Photos

Please don't. Newcomers to the business are understandably anxious to show the world the amazing things they can do with a camera. Nearly every photo they create is a gem. Whoa! Here's where to grab the reins and hold back. Get a qualified professional photographer to evaluate your web site and business card, then cull out the photos that just don't make the grade. *Show only your best work.* Quality trumps quantity!

🚫 DON'T DO IT!

Using a Confusing E-Mail Address

Create an e-mail account with your name combined with numbers that mean something to you. Who can remember numbers? Just because your name is common and mega millions of people on Gmail are using it, don't add a set of numbers to make it unique. Unusual spellings aren't good either. Get real, Frank . . . who can remember Phrank792@

gmail.com? Some web addresses are too long to be realistic for e-mail. Find a way to have a meaningful e-mail address without using numbers or writing a whole sentence!

▼ The most images I have seen on a tiny business card were seventeen individuals and one dog. This type of card will most likely only attract those customers who call to ask the price of an 8x10. It's tempting to "bare all," but restrain yourself and show only a few of your very best images.

MISTAKES 96, 97, AND 98

Pricing, Sales, and Service Errors

🚫 **DON'T DO IT!**

Publishing Prices on Your Web Site

Not a good idea. People who are looking for the cheapest price may not be the customers you want to attract. Providing detailed pricing on your web site also eliminates the need for personal inquiries. You want to be able to engage people in conversation and allow them to become acquainted with your charming personality and sincere customer care approach.

Also, what happens when potential customers print out prices from your site . . . and then you change them? To weed out lookie-loos (or attract bargain shoppers, depending on your target), you can post something like "Portrait Packages start at $795" or perhaps just provide the cost of the session fee for individuals and groups. Specify that prints will cost according to the size and treatment. When your work is good and you have stacked up adequate experience, take the advice of a newspaper owner I once worked for: "You can't sell it if you give it away."

🚫 **DON'T DO IT!**

Not Doing Consultations and Sales in Person

An in-person consultation is the best way for you to convince your potential clients that you offer unique and highly valued photographic services. Explain what they will get and what you expect from them, along with a clear description of the type of photographer you are.

Have examples of your work on the wall—not only so customers can see it, but also to point out different frames and photo finishes (canvas wrap, lustre, linen finish, etc.) that are available. If you do not have a stand-alone studio, try to dedicate a room to small shoots and client consultations.

▲ Having samples of your work on the walls helps clients see your best images and how they can be presented most effectively.

🚫 **DON'T DO IT!**

Letting Customers Print Their Own Images

A true professional offers professional products, not just a CD with photo files. These products might include professionally printed portraits, albums, framing, and more. Even if you only offer professional prints, they will command a much larger commission than a CD alone.

The finest portrait can be ruined by a schlocky printing job rendered from the local pharmacy. Also, clients may have only small prints made—ones that don't show off your excellent work to friends, relatives, and neighbors. What if a client wants a 16x20-inch (or larger) print? Work that large should be printed by a professional lab that offers a sturdy laminated backing to prevent buckling when framed. To be a professional is to provide professional services.

🚫 DON'T DO IT!

Not Joining Professional Organizations

Professional organizations don't just add credibility to your name or your business, they also provide help and valuable support to advance your photographic pursuits. The annual national conventions hosted by PPA and WPPI provide exciting instructional programs by well-known photographers in all genres as well as trade shows with vendors selling the latest photographic gear and goodies. Joining PPA also offers insurance and other professional products. Improve your skills through local guild meetings and print competitions.

🚫 DON'T DO IT!

Using Big-Box Printers Instead of a Pro Lab

Don't take shortcuts. Your clients are smart enough to know the markings that Costco puts on the back of their prints. Make it clear to your clients that you use a professional lab to print their photographs. Establish an account with a professional lab and upload your work to them for processing. Attend national conventions to review the exciting array of products offered by professional labs. Below are just a few of many. It matters little where a pro lab is located because they all provide fast response and delivery time.

Learning and Networking Resources
- Professional Photographers of America—ppa.com
- Wedding and Portrait Photographers International—wppionline.com
- Your local chamber of commerce

Professional Photo Labs
- Bay Photo (CA)—bayphoto.com
- McKenna (IA)—mckennapro.com
- Miller's Professional Imaging (MO)—millerslab.com
- Pounds Labs (TX)—poundslabs.com
- Simply Color (OH)—simplycolorlab.com
- WHCC (MN, TX)—whcc.com

CATEGORY: BUSINESS AND ETHICS

MISTAKES 99, 100, AND 101

Your Professional Image and Growth

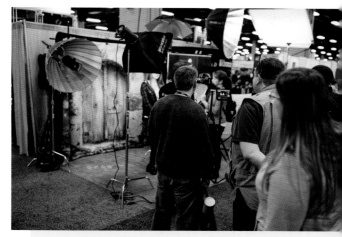

▲ A wealth of instruction and products are available at photographic conventions.

🚫 DON'T DO IT!

Picking a "Clever" Name for Your Business

Photographers who are new to the business spend a lot of sleepless hours trying to think up a fetching name. Cute names and fancy logos are okay—but your own given name provides power and lends real-life credibility to your business. Think about all the high-end photography businesses you know. I'll bet you'll find that most of them are named after the owner. Can you imagine Ansel Adams naming his business "Mystic Mountain Photography" or Anne Geddes hanging out the shingle for "Little Petal People"?

Classic Photographic Standards

Listed here are twelve fundamental rules of thumb. Although these guidelines may sometimes get bent, they are never out of fashion. Learn them well and keep them in the back of your mind—even if your artistic vision leads you to break them.

1. Ever on Your Mind . . .

Never stop thinking "photos." I remember a mentor who said, "If you don't have your camera at your side, you can't take pictures." Simple. Take it everywhere—even when you don't expect to find something to photograph.

Allow your eyes to behold great photos on every side of you, in every corner. Allow photographs to be the nourishment for your creative soul, as food is to your body.

The photos below were all shot within five minutes of each other after the close of a WPPI convention in Las Vegas. There were more, but this is enough to make you aware of the countless opportunities that surround us—if we only keep our eyes open.

▲ This image is an homage to my mother, Magda White, an award-winning photographer and a founder of the "Click Chicks" camera club in Whittier, CA. As a girl, I

was assigned to go out to the log pile on our citrus ranch and catch a lizard for my mother to photograph. She put it in the refrigerator for a few minutes to "slow it down." It worked! The image is not exactly divided into thirds, but the "action" draws the viewer to the lower third corner of the picture. Then the eye wanders delightfully around the image up to the upper right hand corner where the cat's tail peeks over the top of my dad's boot.

▲ Although subtle, the lacy tree in Zion National Park stands out from other subject matter where the thirds intersect. Heavy mountains are in the left third, the horizon and sky lie in the upper third, and the bulk of water is in the lower third.

2. The Rule of Thirds

The Rule of Thirds is the most rudimentary standard in photographic composition. I've mentioned it before, but it bears repeating.

Placing your subject along one of the lines of the grid is almost always a better idea than centering the subject in the frame. Putting your subject at one of the intersections of the lines is like going for the "bonus round," because it places a focal point of interest where the lines intersect.

Because the rule is so effective, it should be paramount in your mind while composing a shot. If you flip through all of the images in this book, you'll see that the majority comply in some way to the Rule of Thirds. That said, a blatant sidestep around this rule can also deliver dramatic results.

3. Leading Lines

Look for dramatic lines to help strengthen all of your photographic compositions. Leading lines provide strength and suggest a path for the viewer's eye to follow in an image. The shapes of leading lines vary. That can be curved (in the form of a C or S) or straight (as either simple diagonal lines or a V shape).

Leading lines should be a key tool in your endeavor to create art.

S Curves

S curves are often found in nature—especially in landscape photography. A photographer's heart goes pitter-patter when seeing a beautiful river snaking languidly through a valley.

◄▼ At Zion National Park, the Virgin River is an S-curve meandering through the canyon (left). Cropping just a bit off the bottom—the S part of the curve—negates the impact of the infrared image (below).

▼ A simple but classic S-curve image.

Diagonal Lines

Often, all it takes to create a dramatic diagonal line is stepping a little to the left or right. It's even better when the endpoint of the line falls on one of the imaginary one-third lines in the frame. A diagonal line in an image lends itself well to stock photography because this arrangement usually leaves room for copy at the top or in the bottom corner. In a scene like the harbor shot (right), shoot both a vertical and horizontal version and submit both.

V Shapes

Classic painters often employed a wedge or a V as an arrow to the VIP in an image (most often the Virgin Mary and Jesus).

C or Circle Shapes

Circular shapes are harder to come by in both the natural and man-made worlds. But when found, they can be extremely compelling.

◄ In this image of a circular stairway, the center of interest falls at an intersection of the Rule of Thirds grid.

▼ Jennifer Bacher created a C shape (in the form of an arch) with water. The girl's flailing wet hair also adds drama to the shot.

▲ Jennifer Bacher used the bunk bed as a framing device for this shot of a girl strumming a guitar. It is almost as though we are taking a peek into a secret hideaway.

▶ Trees make one of the best framing devices in landscape photography. Overhanging branches serve to frame this image of Fountains Abbey in Yorkshire, UK.

4. Frame Your Shot

The technique of framing an image with something in the foreground has been around a long time. All you have to do is be aware of your surroundings to pull in an element that will serve to enclose the subject.

5. Sunny 16 Rule

The Sunny 16 rule can't be trumped by technology; it has been in use since tin plates and is still holding strong. Simply stated, it is a basic method of establishing a correct expo-

sure outdoors without using a light meter. This rule gets its name from the f/16 aperture. This already makes it easy to remember. Here's how to apply the rule.

While shooting outside on a clear, sunny day, set your aperture to f/16. Then, set your shutter speed to correspond to your working

Sunny 16 Rule

(Reciprocal ISO and Shutter Speed (i.e., 100 ISO at $\frac{1}{100}$ second or 400 ISO at $\frac{1}{400}$ second)

Conditions					Sunset
Aperture	f/16	f/11	f/8	f/5.6	f/4

▲ While learning the Sunny 16 Rule, make a copy of this simple chart to keep in your camera bag.

ISO setting. For example, if your camera's ISO is set at 100, the correct sunny-day exposure should be f/16 at $\frac{1}{100}$ second. Similarly, if your ISO is 400, the shutter speed should be $\frac{1}{400}$ second, and so on.

What if it is a hazy day? You will need more light in your camera, right? So open up a half stop to f/11.5. Cloudy? Open up a full stop to f/11. If it's pouring rain, open 2 stops to f/8.

While learning this rule, I recommend keeping a copy of the simple graph above taped to your camera strap or camera bag. Here's another quick tip: Some photographers lift their foot and evaluate the light (and, therefore, what settings to use) by the sharpness of the shadow underneath. For example, a very sharp shadow means it is nice and sunny.

6. Catchlights

High on the list of "important photographic techniques" is watching the catchlights in the eyes of your subject. Catchlights breathe life into a portrait. There's a dark, dead look to a person when their eyes show no hint of light. Many professionals will insert or enhance catchlights in post-processing if none were there during capture.

◄ These catchlights were created by just one umbrella-type F.J. Westcott softbox with six daylight-balanced "Spiderlites" inside.

7. Reciprocal Rule

This rule may be the most neglected by new photographers—yet it is a rule that should be followed with no exceptions for "creativity." The Reciprocal Rule is used to determine the slowest shutter speed at which you can safely hand-hold your camera with little danger of blur. The rule states that the shutter speed should not be slower than the reciprocal of the effective focal length of the lens you are using. For example, if you have a 50mm lens, your camera should be set at $\frac{1}{50}$ second or higher. If you change to a 70–200mm lens, you would need to shoot at a minimum of $\frac{1}{70}$ second and $\frac{1}{200}$ second if zoomed in to 200mm. Easy, no?

8. Uneven Rule

This is an easy one. When photographing a group (whether inanimate objects or people), it is best to have uneven numbers—such as 3, 5, or 7. Don't leave out a family member just to make an uneven number, of course! Another exception would be a bride and groom (as they say, "Three's a crowd!").

9. Tell a Story

Everyone loves a story. Imagine storylines in advance of your photo sessions, and keep looking for them while you shoot. Capture stories when they present themselves. A lot of storytelling success lies under your control and can be developed through your dialogue

▶ **TOP** – Groupings of three make for a pleasant configuration.

▶ **CENTER** – Can't you just hear these kids in the back of a car – giggling one moment, then shrieking the next? What mom doesn't remember those traumatic scenarios when the kids are tormenting each other? It's only a matter of time before someone breaks out in tears. This "bigger-than-rearview-mirror" glimpse is a storytelling visual that goes along with a loud narrative of, "Hey, guys – cut it out back there!"

▶ **BOTTOM** – This candid image carries with it a subtle story. The young girl hugging her bear is in her everyday dress – a cross between ballerina and hippie.

▲ Warning: tilting a horizon full of water may seem like something the early sea explorers feared: falling off the edge of the earth.

◄ Take care not to tilt too much; keep the angle well below 45 degrees.

with the client. Keep clients interested in the emotions and ideas that come to their minds as they recount incidents from their lives.

10. Dutch Tilt

Photographing with the camera tilted at an angle (also called the "Dutch Tilt" or "Dutch Angle") has become a popular photographic technique. These tilted angles were first used to set a darker mood in an image. In the *Batman* television series and films, for example, each villain had his or her own angle. Now, however, it is applied to just about anything.

11. Negative Space

A successful image doesn't always have to feature imagery stretching out to all corners. Empty space can create a powerful look.

◄ Use negative space to express mood, intrigue, or design.

► **TOP** – Joel Grimes broke the Rule of Thirds with great aplomb in this image. He suggests that it takes more hard work than talent to become a success in the photographic arena. "Even a poor idea can be executed brilliantly."

► **BOTTOM** – Betsy Tomasello played off the majesty of the green hills and the power of the sun to create this striking photograph of her subject directly in the middle of the frame. This image also breaks the rule of not shooting into the sun.

12. Break the Rules

Mastering the rules gives photographers even more power: the power to create stunning images by breaking them! We've already looked at a few instances in which breaking the Rule of Thirds made for a better image.

Another current popular rule-breaker is to shoot into the sun. The normal rule of thumb is to place the sun behind or at the side of a subject. However, backlighting can turn a ho-hum image into something spectacular. This effect is also known as contre-jour (French for "against daylight"). Contre-jour produces backlight on the subject, creating silhouettes and emphasizing shapes. By setting the aperture as high as it will go (most likely f/16 or f/22), you might even be lucky enough to catch some beautiful sun rays.

> **"** Backlighting can turn a ho-hum image into something spectacular. **"**

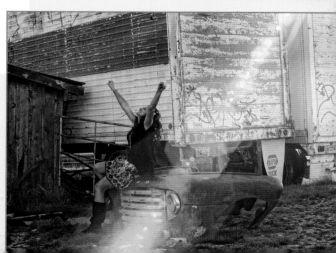

► **TOP** – Jennifer Bacher shot into the sun for a dramatic photograph of a family at the beach.

► **BOTTOM** – A high aperture setting (f/20) helped capture a sun ray streaking through this backlit image.

Index

Photographing Children with Special Needs

Karen Dórame explains the symptoms of common conditions and offers tips for conducting a safe shoot. *$29.95 list, 8.5x11, 128p, 100 color photos, order no. 1749.*

Portraiture Unleashed

Travis Gadsby pushes portraiture in exciting new directions with design concepts that are sure to thrill viewers—and clients! *$34.95 list, 7.5x10, 128p, 200 color images, order no. 2065.*

THE PHOTOGRAPHER'S GUIDE TO
Making Money

Karen Dórame provides 150 surprising tips for cutting costs and boosting profits. *$34.95 list, 8.5x11, 128p, 200 color images, index, order no. 1887.*

Portraiture Unplugged

Carl Caylor demonstrates that great portraiture doesn't require a studio or pricey gear. Natural light can give you outstanding results! *$27.95 list, 7.5x10, 128p, 220 color images, order no. 2060.*

Mastering Infrared Photography

Karen Dórame takes you on an adventure through creating amazing images with invisible light. *$37.95 list, 8.5x11, 128p, 230 color images, index, order no. 2075.*

Digital Black & White Landscape Photography

Trek along with Gary Wagner through remote forests and urban jungles to design and print powerful images. *$34.95 list, 7.5x10, 128p, 180 color images, order no. 2062.*

Senior Style

Tim Schooler is well-known for his fashion-forward senior portraits. In this book, he walks you through his approach to lighting, posing, and more. *$29.95 list, 7.5x10, 128p, 220 color images, index, order no. 2089.*

500 Poses for Photographing Full-Length Portraits

Michelle Perkins shares inspiring images to help you conceptualize and deliver the perfect full-body poses. *$34.95 list, 8.5x11, 128p, 500 color images, order no. 2059.*

Shot in the Dark

Brett Florens tackles low light photography, showing you how to create amazing portrait and wedding images in challenging conditions. *$29.95 list, 7x10, 128p, 180 color images, index, order no. 2086.*

Smart Phone Microstock

Mark Chen walks you through the process of making money with images from your cell phone—from shooting marketable work to getting started selling. *$29.95 list, 7x10, 128p, 180 color images, index, order no. 2092.*